GREEN
FLOWERS

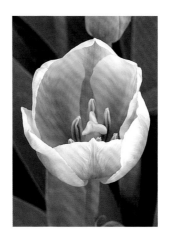

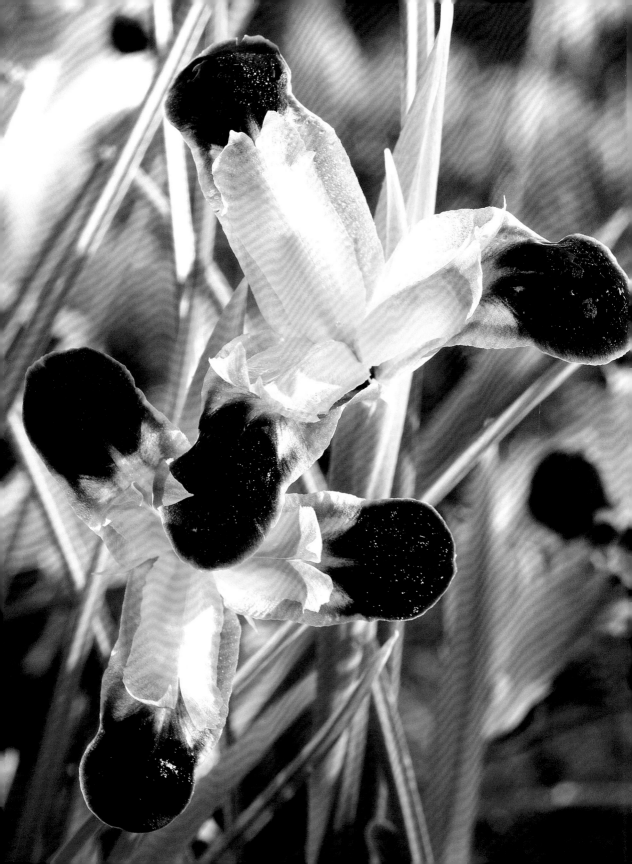

GREEN
FLOWERS

*Unexpected Beauty for the
Garden, Container or Vase*

Alison Hoblyn

Photographs by
Marie O'Hara

Timber Press
Portland | London

Page 1

Tulipa 'Spring Green'

Frontispiece

Hermodactylus tuberosus

Dedicated to Anne Metcalfe

Grateful acknowledgement is given to Eric Glass Ltd for permission to reproduce a passage from Beverley Nichols's *Forty Favourite Flowers*, published in the UK by Studio Vista in 1964.

Published in 2009 by Timber Press, Inc.

The Haseltine Building 2 The Quadrant
133 s.w. Second Avenue, Suite 450 135 Salusbury Road
Portland, Oregon 97204-3527 London NW6 6RJ
www.timberpress.com www.timberpress.co.uk

Designed by Dick Malt
Printed in China

Library of Congress Cataloging-in-Publication Data

Hoblyn, Alison.
 Green flowers : Unexpected Beauty for the Garden, Container or Vase / Alison Hoblyn ;
photographs by Marie O'Hara.
 p. cm.
 Includes index.
 ISBN 978-0-88192-919-5
 1. Perennials—United States. 2. Ornamental trees—United States. 3. Ivy—United States. 4. Herbs—United States. I. O'Hara, Marie, photographer. II. Title.
 SB434.H63 2009
 635.9—dc22
 2008041891

A catalogue record for this book is also available from the British Library.

Contents

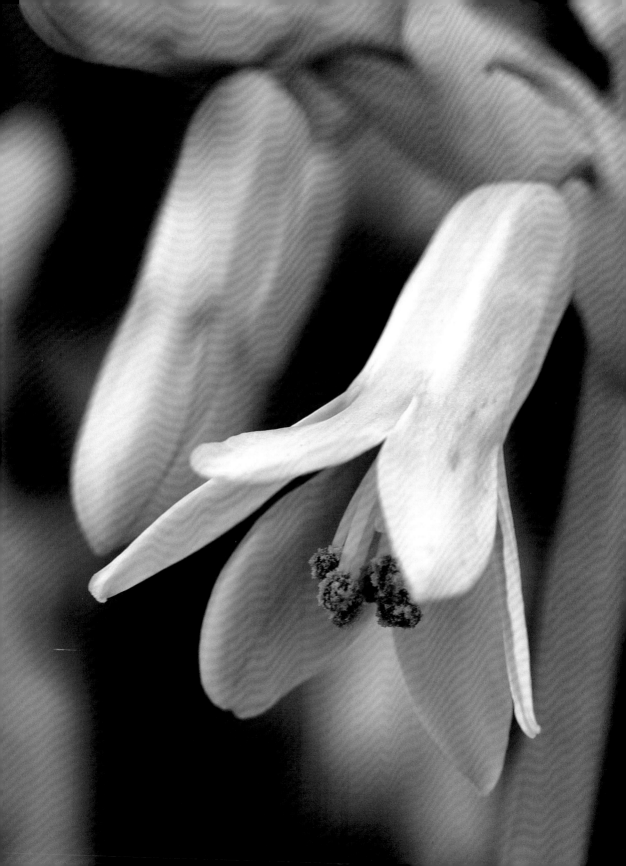

Introduction

Opposite

Galtonia viridiflora

"Simple and sophisticated, mysterious and elegant: green is beautiful."
—Anne Metcalfe

As a painter and a gardener, I have always appreciated green for its neutral and restful qualities. On the colour wheel, it occupies that middle land between the hot hues of red and the colder climes of blue. Within the realm of green, there is such great diversity; greens that tend towards blue can be jade or viridian, while those that have more than a dash of yellow in their mix can be parrot-green or lime or chartreuse. Dirty up the mix with a little black to give a greyer green and you may find celadon. Add a little red and green warms up, lilting towards brown.

Then there is tone to consider. Each of those hues can be darker or paler—imagine diluting lime cordial with water—and then the colour takes on another characteristic altogether. Now relate that to a plant with its own unique form and texture—think of *Angelica archangelica* or *Hacquetia epipactis*—sitting in a place with varied light and shade, and you can see how using green in the garden can never be an exact science! Colour is always affected by its context; if light reflects from a brightly coloured flower, it will subtly change the hue of its neighbour.

And it may be difficult to tell where green ends and another colour begins. Take an outer petal of *Clematis florida* 'Plena'—which, objectively, is white—and place it on a piece of snow-white cartridge paper; you will perceive a green-greyness in it. Look at a petal of *Tulipa* 'Spring Green' and the dash of green running down the middle of the flower petal makes the rest of it look white, until closer inspection reveals this 'white' to be a pale shade of yellow.

Naturally, when one thinks of green in horticulture, one thinks of foliage—and there is plenty of that to choose from, in leaf form and colour. What this book aims to introduce are the extraordinary plants that have green flowers—or at least what will pass for a green flower

to the gardener's eye. In some cases the 'bloom' is actually made of bracts or modified leaves but, for all intents and purposes, it creates the effect of a flower.

The green colour of plants is produced by chlorophyll, a molecule that is key in converting light into energy that the plant draws upon in order to grow. Simply, it is a kind of solar power cell that happens to be green. Displaying pink, orange or purple flowers is how many plants call out to pollinators, but many of the flowers in this book are green because they don't have to flaunt themselves. They have no need for loud colour to attract insects or birds to spread their pollen, as they either propagate through asexual reproduction (like *Alchemilla conjuncta*), or use the wind to do their meeting and greeting. What I find unique about green flowers is this humility; it is as if they don't feel the need to engage in a great show, but require a different kind of appreciation from the world.

In the absence of flashy hues, the diverse shapes and structures of green-flowered plants come to the fore. The fans of hairy, hand-like flowers of *Anigozanthos flavidus*, the four teardrop-shaped, paper-like bracts that mimic petals on the Kousa dogwood, and the fluffy green flowers that adorn the slender stems of the grass *Setaria viridis* represent only a fraction of the striking, often highly sculptural forms that they take.

I choose green in a planting scheme for many reasons. For one, it makes a marvellous bridge between more loudly coloured plants; the blue-green foliage and silvery green flowerheads of *Echinops sphaerocephalus* makes an interesting structured companion to both blue delphiniums and yellow *Achillea* 'Moonshine'. It provides a kind of comma, somewhere to rest the eye between stimulating and opposing coloured areas. The underlying blue tone of the glaucous foliage harmonizes with the delphinium flower and is complementary to the yellow achillea, while the paleness of the frosted green flowerhead works well with the lightness of tone of *A*. 'Moonshine'. Whereas the blue-green is used here to make peace, there is nothing more wonderful than the almost conflicting sparkiness of fabulous bright acid-green *Euphorbia characias* set against dark burgundy-black 'Queen of the Night' tulips.

Imagine this combination brought into the house in a flower arrangement where the effect will be even more striking. Green is the

flower-arranger's friend, helping to show off complementary reds and pinks or harmonizing with yellows and blues. But it need not be just a background player; with all the green flowers in this book there is ample scope to produce a stunning, green-dominated arrangement that concentrates on shade, tone and structure.

I enjoy using greens together, without other colours; an all-green planting gives an opportunity not to be distracted by showy hues and instead look hard at the form of the plant. And that is what gardeners like to do: to look, to take some precious moments to appreciate something that will last just a short while. Close scrutiny of some of the tinier examples in this book, like *Jovibarba heuffelii* 'Bloodstone' or *Mitella breweri*, will be repaid with that rare sensation: a feeling of wonder. Browsing the gallery of photographs is a good way to begin appreciating the perfection of their intricate forms.

The colour green has so many associations. It is not only applied as a descriptor of colour but also conjures strong feelings—of envy and nausea, maybe. To some it means new beginnings, while for others it is alternately lucky or unlucky. The word has been hijacked politically to evoke an altogether worthy notion of eco-friendliness. Rather remarkably, exposure to the colour green has been found to slow the heart rate and lower blood pressure—and above all, it is the colour of nature, associated with creation. With all these images attached to one simple word—green—I've tried to provide as objective a colour description of these plants as possible. In the following pages you will find a wealth of plants to choose from, ranging from houseplants to trees. I hope this will give you a thought-provoking and useful palette of flowering greens to enjoy in the house and the garden all year round.

Acanthus hirsutus

Type of plant
herbaceous perennial

Hardiness
USDA Zones 8–10

Position
sun or partial shade

Height
15–35 cm (6–14 in.)

Spread
up to 30 cm (12 in.)

Acanthus figures prominently in Classical architecture; the strong design of the deeply divided leaf was used to decorate columns of the Corinthian and Composite orders.

This clump-forming perennial has a dramatic presence despite being of smaller stature than the commoner *Acanthus mollis*. At its base are spiky dark green leaves, out of which erupt spires made up of cream to greenish white flowers and hairy, spiny, yellow-green bracts. The flowers appear from late spring to midsummer, their paleness making an interesting contrast against the leaves.

Care and cultivation
Acanthus hirsutus thrives in fertile, well-drained loam but can tolerate short periods of drought. It flowers most generously in the sun, and responds to shade by producing shorter growth and a greater quantity of larger and darker leaves. Cut back flower spikes after flowering. Once established, it may be hard to eradicate as it tends to spring up from any piece of severed root.

Uses
A great architectural plant, it brings structure or a focal point to the garden and works equally well in cottage-garden-style planting. It may need to be confined due to its rampant tendencies. It works well on banks, and in tubs and pots.

The fresh flower spikes are dramatic in flower arrangements (beware of spines when cutting), and they also dry well. Prepare for fresh arrangements by plunging the first 2.5 cm (1 in.) of stalk into boiling water for twenty seconds; for drying, hang heads upside-down in a cool, dry place.

Other recommendations
Acanthus syriacus (syn. *A. hirsutus* var. *syriacus*): produces dark green foliage, and greenish white flowers with purple bracts. Height 60 cm (24 in.).

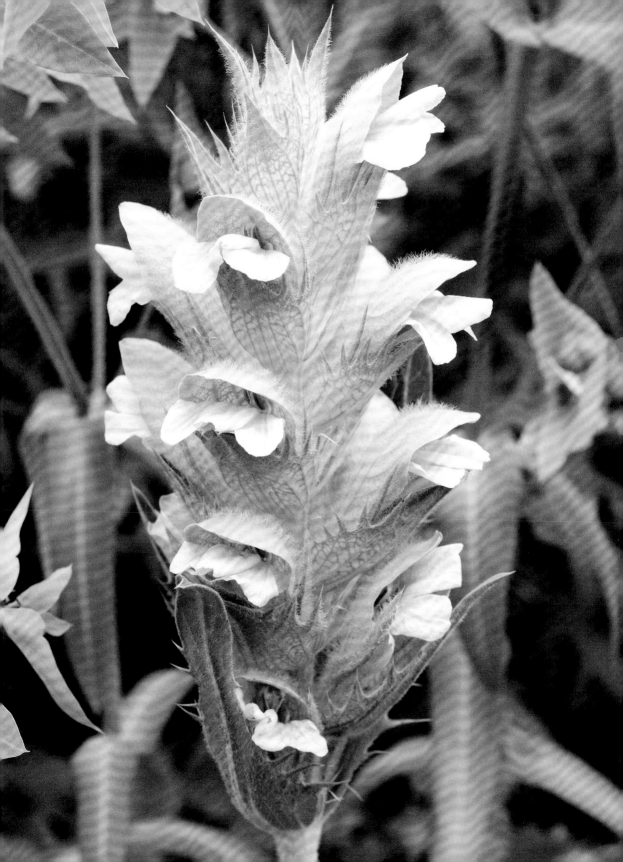

Acer palmatum 'Atropurpureum'

Japanese maple

Type of plant
tree

Hardiness
USDA Zones 5–8

Position
sun or partial shade

Height
8 m (26 ft.)

Spread
10 m (33 ft.)

Maples cover a large part of North America, being the major component of many of its deciduous forests. The cultivars are legion, but all maples are known for their fiery autumn colour.

Commonly known as the Japanese maple, this variety of *Acer* is best known for its red-purple leaves. However, in the spring, they unfurl in a luscious green colour, accompanied by tiny, greenish yellow flowers that hang gracefully from their stems. Not only is the sight of early spring sunlight illuminating the fresh flowers and foliage a real delight, but there is also the added bonus of dark red colouring in summer.

Care and cultivation

Grow in fertile, moist but well-drained soil, in sun or partial shade. Protect it from cold winds and from late frosts, which may kill the young leaves. Where temperatures fall below –10°c (14°F), mulch its roots in the autumn. From late autumn to midwinter, prune by removing wayward or crossing shoots, and any dead wood, to maintain a healthy framework. *Acer palmatum* 'Atropurpureum' can be grown in a container but doing so will restrict its growth; it also needs to be kept well watered in this situation.

Uses

As a specimen tree, it makes a fine focal point in a lawn, border or container.

Other recommendations

Acer capillipes (snake-bark maple): flowers are greenish white, appearing in early to late spring. The foliage is green with good autumn colour, and the bark is smooth, greenish and streaked white. Height 8–10 m (24–30 ft.).

Acer palmatum 'Deshojo': smaller in scale, the flowers are green and blush red in late spring. The leaves of this cultivar are shrimp-pink in spring and turn green in summer. Height 2.5 m (8 ft.).

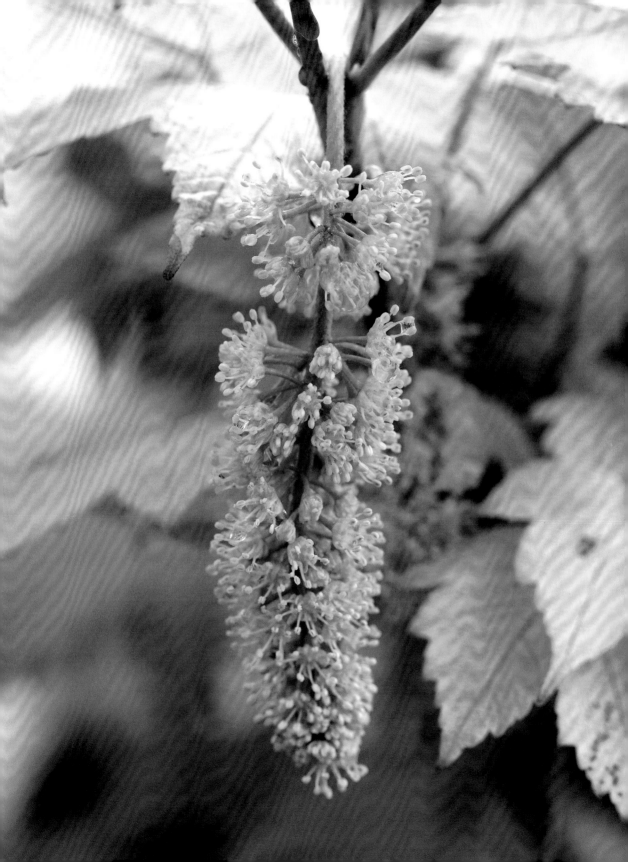

Albuca shawii

Type of plant
bulbous perennial

Hardiness
USDA Zones 7–11

Position
sun

Height
20–40 cm (8–16 in.)

Spread
20–30 cm (8–12 in.)

Summer-flowering bulbs tend to be of exclamatory size—think of lilies and (if we include tubers in this category) gladioli and dahlias. Albucas help to extend the season of smaller-scale spring-flowering bulbs.

The flowers of this South African native are nodding bells of yolk-yellow, garnished with a central stripe of olive-green on each petal. They are borne in profusion and usually last all summer long, making *Albuca shawii* a great specimen plant for a warm, sheltered position. These waxy-looking flowers have a sweet fragrance, and the linear foliage also exudes a fragrant aroma when bruised.

Care and cultivation

In frost-prone areas, grow in a temperate greenhouse; in warmer areas, use in an open, sunny site. Plant bulbs 5 cm (2 in.) deep in spring. Outdoors, grow in reasonably fertile, well-drained soil in full sun. Albucas should be kept dry when dormant in late autumn to mid spring.

Uses

Good for a sheltered sunny position or a cool greenhouse. Plenty of watering throughout the summer encourages it to flower, enlarge and set seed. It is ideal for a pot on the patio where it may achieve greater dimensions, but should be brought in and kept dry all winter. *Albuca nelsonii* (below) is a particularly good cut flower.

Other recommendations

Albuca aurea: produces yellow-green, sweetly scented flowers with wide green stripes outside. They thrive in full sun. Give moderate water when growing; otherwise, keep rather dry with good drainage. Good for pot culture. Not frost-hardy; lift border bulbs in autumn. Height 30 cm (12 in.).

Albuca humilis: has pale yellow flowers with wide green central stripes, blooming in late spring and early summer. Half-hardy; will survive in a sheltered site, mulched in winter. Height 50 cm (1.5 ft.).

Albuca nelsonii: produces almost-erect, tubular white flowers with wide green stripes. Good for cutting. Flowers late spring and early summer. Height 1.5 m (5 ft.). For greenhouse culture; minimum temperature 7°C (45°F).

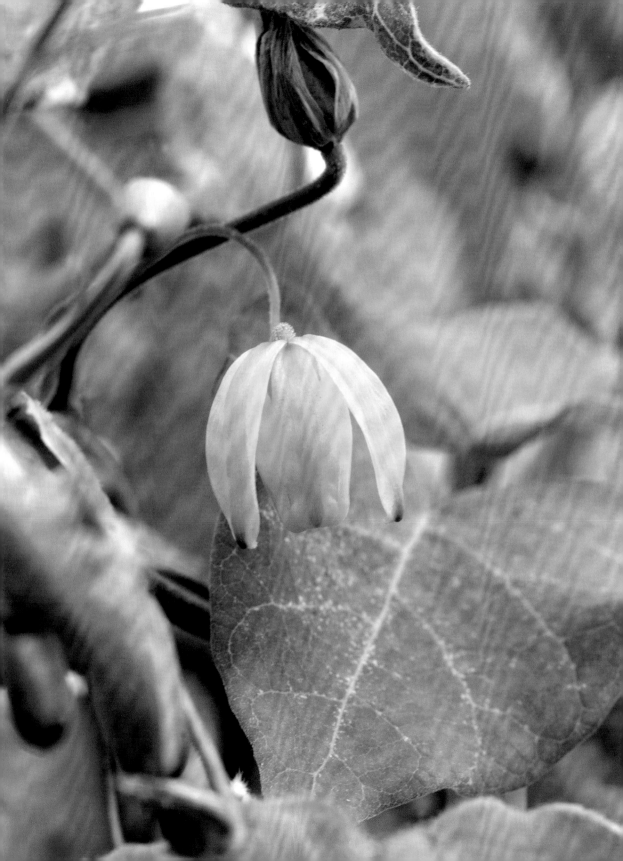

Alchemilla conjuncta

Type of plant
perennial

Hardiness
USDA Zones 3–9

Position
sun or partial shade

Height
40 cm (16 in.)

Spread
30 cm (12 in.)

This neat, clump-forming perennial bears frothy clusters of tiny yellow-green flowers from early summer to early autumn. More compact than the better-known *Alchemilla mollis*, it has virtually the same habits. At its best, it is not only a beautiful plant but also incredibly obliging, sowing itself into paving cracks, placing itself beneath garden seats and, in general, providing a comfortable and settled look. The scalloped leaves are blue-green and, after rain or dew, retain light-reflecting water drops that look like quicksilver. It seeds profusely, producing fertile seed by asexual reproduction—a useful characteristic if the viral threat to the world's honeybee population continues to grow apace.

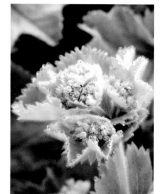

*Alchemilla
mollis*

Care and cultivation
Enjoys any moist, humus-rich soil in sun or partial shade and is tolerant of drought. Dead-head soon after flowering, as it self-seeds very freely.

Uses
Suitable for a wildflower planting, large rock garden or mixed border and excellent as ground cover. Flower-arrangers value alchemillas for their longevity when cut, their mouth-watering colour and the airiness of their flowers.

Other recommendations
Alchemilla mollis: a clump-forming perennial with softly hairy, pale green leaves. It has loose clusters of tiny, greenish yellow flowers from early summer to early autumn. Drought-tolerant, excellent for ground cover and for cut flowers. Height 60 cm (24 in.).
Alchemilla erythropoda: even smaller at 13 cm (5 in.) high, this plant displays very blue-green leaves when placed in a sunny position.

Alchemilla *means 'little alchemist' and refers to the practitioners who aimed to turn base metals into gold during the Middle Ages. Alchemists required the purest dew for their experiments, and this was gathered from the leaves of alchemillas.*

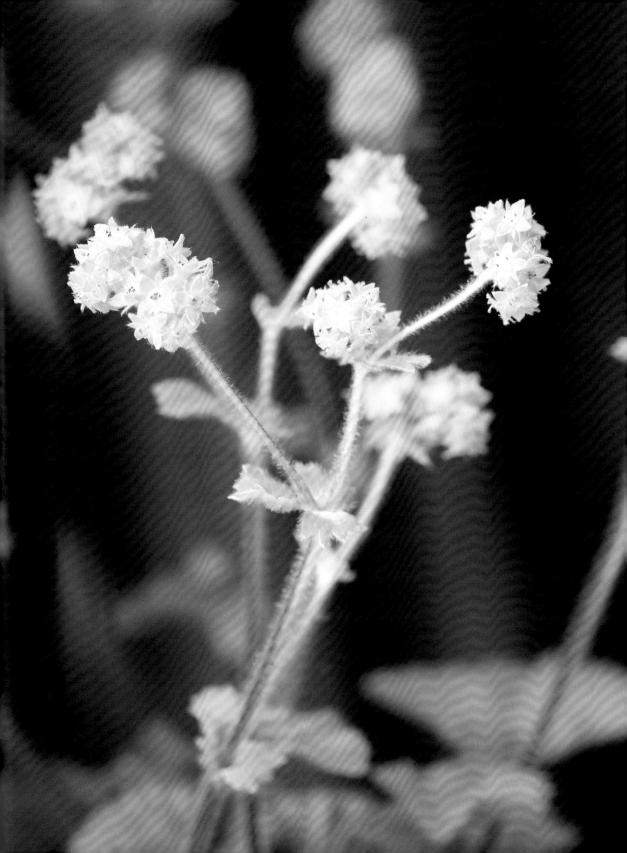

Allium obliquum

twisted-leaf garlic

Type of plant
bulbous perennial

Hardiness
USDA Zones 3–8

Position
sun

Height
60 cm (24 in.)

Spread
5 cm (2 in.)

Allium obliquum and A. sphaerocephalon are both in the onion family. They are like onions in the way that they spread: a single bulb produces clusters of offset bulbs around it. (Sometimes A.sphaerocephalon will produce bulbils, or tiny bulbs growing like buds in the flowerhead.) Like these green-flowered alliums, onions or leeks may also be grown for their decorative flowerheads.

When most gardeners think of alliums, the image of a round purple flower comes to mind—and many alliums do take this characteristic form. But with the arrival of many new cultivars over the last twenty years, the colour range of this genus has expanded from near-blue to rich claret. *Allium obliquum* has a dainty, yellow-green, spherical flowerhead, measuring about 2.5 cm (1 in.) across, which is made up of small flowers with rays of protruding stamens that give it a star-like quality in midsummer. These lemony green flowers contrast nicely with the stiff upright stems and foliage, which have a blue cast.

Care and cultivation
Allium obliquum is a clump-forming species with rhizomes; it should be planted at the soil surface (or just below it) in spring. Grow in fertile, well-drained soil in full sun. This plant tends to be slow to increase its clump size. Avoid direct contact with the bulbs as they can irritate skin.

Uses
Best planted in groups, in a sunny border. When flowers are freshly cut, they emit the distinct aroma of onions. Flowerheads dry well; hang upside-down in cool, dry place.

Other recommendations
Allium sphaerocephalon (round-headed leek): a bulbous perennial that produces tightly packed green oval flowerheads topped with dark maroon flowers. Height 50–90 cm (20–36 in.).
Allium sphaerocephalon **'Hair'**: a mutation of the above, it has green tendrils of 'hair' erupting from its flowerheads in early summer. Height 90–100 cm (30–36 in.).

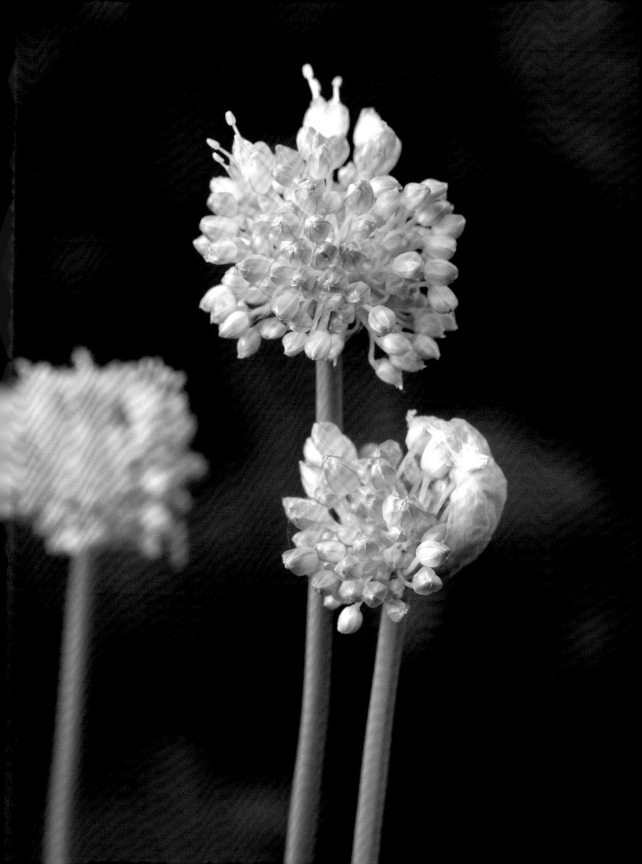

Amaranthus caudatus 'Viridis'
love-lies-bleeding

Type of plant
herbaceous perennial

Hardiness
USDA Zones 8–11

Position
sun

Height
1–1.5 m (3–5 ft.)

Spread
45–75 cm (18–30 in.)

The seeds of certain Amaranthus *species such as* A. hypochondriacus *contain twice as much calcium as milk. They can be eaten raw or cooked, or even 'popped' in much the same way as popcorn. The grains offer a rare complete source of plant protein and are also a good source of iron, magnesium and fibre.*

In summer and early autumn, the flowers of *Amaranthus caudatus* 'Viridis' bring an air of exoticism to the temperate garden. These flowers are like tassels, borne in generous swags from the end of the stems. They start an arresting electric-green before fading gradually to cream over the life of the flower. Multicoloured seedheads soon follow.

Care and cultivation
Outdoors, grow this half-hardy plant in reasonably fertile, humus-rich, moist soil in full sun in a sheltered site. In dry periods in summer, water freely to prolong flowering time. Where there is a chance of frost, it needs to be treated as an annual summer bedding plant. In a greenhouse, grow in loam-based potting compost in full light; provide high humidity, and water well in summer.

Uses
Amaranthus caudatus 'Viridis' looks very striking in pots or hanging baskets. It may also be grown as a short-lived houseplant or in a temperate, humid greenhouse. It makes for a distinctive focal point in an annual bed or herbaceous border, and looks equally good with small shrubs and other green-flowering or foliage plants. Makes a great cut flower; remove the lower leaves and sear stems for twenty seconds in boiling water before plunging them into cold water. The stems can also be dried for winter colour.

Other recommendations
Amaranthus cruentus **'Towers Green'**: has masses of soft, yellow-green florets on columnar spikes with a much taller central stem, flowering midsummer to early autumn. Medium-green to purple foliage. Height 1 m (3 ft.) at central 'tower' (about 70 cm [28 in.] at flower spikes). Use as an annual as it is frost tender.
Amaranthus hypochondriacus **'Green Thumb'**: produces brilliant yellow-green flowers and long-lasting emerald-green spikes. Height to 60 cm (24 in.).

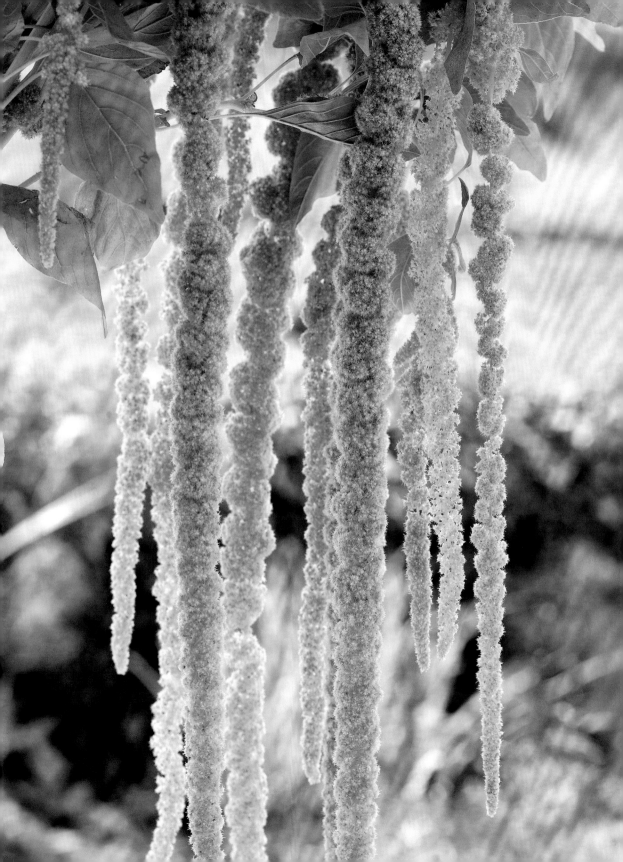

Anemone nemorosa 'Virescens'

Type of plant
rhizomatous perennial

Hardiness
USDA Zones 3–8

Position
partial to full shade

Height
10 cm (4 in.)

Spread
20 cm (8 in.)

Take care when handling Anemone nemorosa as all parts of the plants contain poisonous chemicals that can be harmful to humans and animals. The active toxin is protoanemonin, which can cause skin and gastrointestinal irritation.

The fruity green of *Anemone nemorosa* 'Virescens' seems to glow in the midst of awakening spring woodland. It actually has no flower petals, but displays finely cut, pale green bracts, or modified leaves. Their freshness is appealing from early to late spring, but by midsummer the foliage dies back, leaving little to no trace of the plant's existence. Although each plant is small, they can spread and join together to provide a mat of luminous ground cover.

Care and cultivation

This plant will do well in full shade, but it responds to extra light by blooming more freely. It likes moist yet well-drained humus but, when dormant in summer, can withstand some lack of water. Because it spreads by underground root-like stems (rhizomes) near the soil surface, it will naturalize very well if given the right conditions.

Uses

An excellent early-flowering addition to the perennial border, it works well under trees as ground cover.

Other recommendations

Anemone nemorosa **'Viridiflora'**: like *A. nemorosa* 'Virescens', it has no petals—just green leaflets with a white speckled effect. Establishes easily in shade, even dry shade. Height 15 cm (6 in.).

Anemone nemorosa **'Green Fingers'**: produces white blooms with frilly green centres. Slightly less hardy than 'Viridiflora'. Height 15 cm (6 in.).

Anemonella thalictroides 'Double Green'

Type of plant
perennial

Hardiness
USDA Zones 4–8

Position
partial to full shade

Height
10–20 cm (4–8 in.)

Spread
30 cm (12 in.)

Anemone means 'wind flower' in Greek—thus the word Anemonella *refers to a* small *wind flower, and the plant does indeed resemble a little wood anemone. The species name of* thalictroides *refers to the dark green three-lobed leaves which look like those of* Thalictrum.

Anemonella thalictroides is a North American native. An elegant perennial, it grows from tubers to form small clumps of healthy foliage that are happy in a shady part of the garden. 'Double Green', a cultivar from Japan, has delicate apple-green-tinged double flowers that rise on slender stems above blue-green leaves in mid to late spring.

Care and cultivation

Slow to establish, it will eventually form mounds up to 30 cm (12 in.) across. Grow in partial shade in moist, humus-rich soil, even if it is on the sandy side and not hugely fertile. The tubers may rot in very wet soil.

Uses

Good in a woodland garden, for underplanting shrubs or in a shaded rock garden.

Other recommendations

Anemonella thalictroides **'Green Dragon'**: a curious double-flowered form with twisted white-green to yellow-green petals and long-lasting flowers. Height 10–20 cm (4–8 in).

Anemonella thalictroides **'Green Hurricane'**: another double white-green-flowered flowered form with the same dimensions (and hardiness) as 'Double Green'. Height 10–20 cm (4–8 in.).

Angelica archangelica

wild parsnip

Type of plant
herbaceous perennial, often
grown as a biennial

Hardiness
USDA Zones 4–9

Position
partial or full shade

Height
2 m (6 ft.)

Spread
1.2 m (4 ft.)

*Angelica is Latin for
'angelic'; ancient lore
tells of a monk who was
informed of the plant's
medicinal properties—
including its supposed
ability to cure plague—
by an angel. Angelica is
still used in many ways in
modern medical herbalism
as a calming agent, a
stimulant, a tonic and a
treatment for coughs.*

Angelica archangelica, commonly known as the wild parsnip, towers over most other herbacous planting, providing both a strong vertical element and a 'wild' feeling in the garden. Its flowerheads can achieve a magnificent 25 cm (10 in.) across. From early to late summer, dramatic, convex arrangements of flowerheads are held high on thick-ribbed green stems. The architectural shape, extravagant height and fresh yellow-green flowers make *A. archangelica* an exciting focal point in a design scheme.

Care and cultivation

In the wild, angelicas live mainly in woodland or on streambanks; ideal conditions include deep, moist, fertile, loamy soil and full or partial shade. However, *A. archangelica* is capable of tolerating drier conditions, or more sun if its roots are moist. *Angelica archangelica* generally dies after flowering, but if flowering is prevented (for example, by removing the flowers before they set seed), it may flower for a second year.

Uses

This plant sits well on the edge of a pond or stream, and is also at home in a herb garden. It makes a bold cut flower; sear the bottom 2.5 cm (1 in.) of the stem for twenty seconds in boiling water before refreshing in cold water. All parts of the plant are aromatic, and the stems are often candied.

Other recommendations

Angelica atropurpurea (purple-stemmed angelica): a perennial that produces white-green flowers in the summer. Stems are thick, reddish and hollow. Height 60 cm–2.4 m (2–8 ft.).
Angelica taiwaniana: has large globular heads of scented green and white flowers. Height 1–2 m (3–6 ft.).

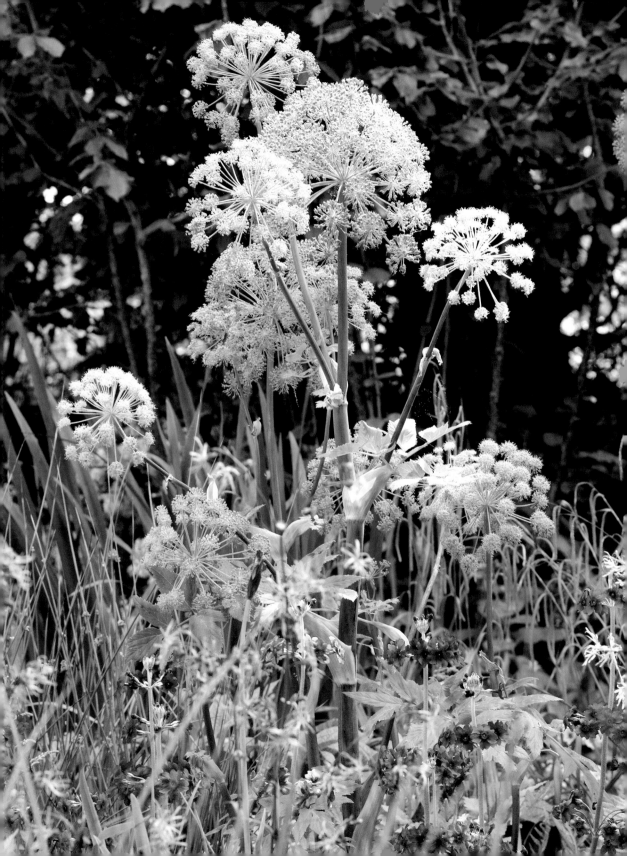

Anigozanthos flavidus

kangaroo paw

Type of plant
evergreen perennial

Hardiness
USDA Zones 9–10

Position
sun

Height
1–3 m (3–10 ft.)

Spread
60–80 cm (24–32 in.)

An intriguing-looking exotic originating in Australia, *Anigozanthos flavidus* will not withstand frost but can provide a curious talking point in a summer border, greenhouse or conservatory. The fans of up to ten hairy flowers appear almost hand-like—hence the common name. From late spring to midsummer, the hue of these tubular blooms changes from the colour of overripe apples to a brownish green; their very tips curl back to produce star-like shapes and reveal bright stamens.

Care and cultivation

Anigozanthos flavidus flowers from spring to midsummer outdoors, but under glass it may flower at any time of year depending on light conditions. It hybridizes freely, both in the wild and in cultivation. In the greenhouse, grow in full light, and at a minimum of 5°C (41°F); pot up in three parts leaf mould to one part loam plus one part sharp sand. Water freely in spring and summer, applying a balanced liquid fertilizer every month, but keep almost dry in winter. Outdoors, grow in moist but well-drained, humus-rich, sandy loam in full sun. Water regularly during dry periods, and use a deep mulch in autumn to protect the crowns.

Uses

In frost-free regions, use to add interest to a border; otherwise, grow in a cool greenhouse or conservatory. It makes an excellent cut flower that is sure to be a talking point.

Other recommendations

The following are best suited to greenhouse cultivation where the temperature is at least 5°C (41°F).

Anigozanthos **'Bush Emerald'**: a clump-forming perennial with glaucous blue-green leaves, red-purple stems and yellow-green flowers that bloom in late spring to midsummer. Height 60–100 cm (24–36 in.).

Anigozanthos manglesii: a clump-forming perennial with grey-green leaves. Red-hairy stems with yellow-green flowers mid spring to early summer, grading to dark green with lime-green hairs outside. Height 30–120 cm (12–48 in.).

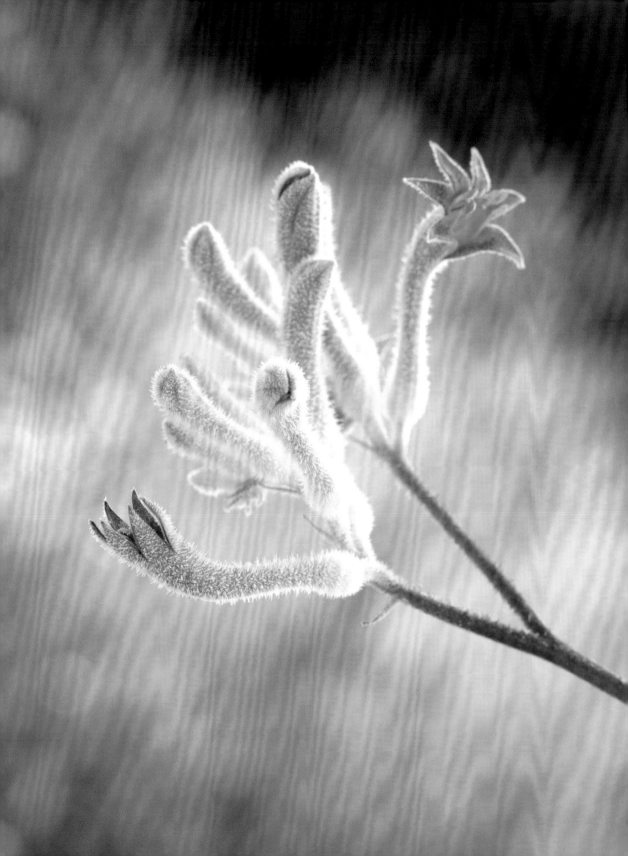

Anthurium 'Midori'

Type of plant
evergreen perennial

Hardiness
USDA Zones 10–11

Position
light and humid

Height
50 cm (20 in.)

Spread
50 cm (20 in.)

Anthuriums are sometimes known as tail flowers in reference to the shape of their spathe and spadix.

Anthuriums are easy to spot in florists' confections due to their dramatic spathes that look like flattened upturned leaves, as well as their 'finger-pointing' spadices—the fleshy flower spikes that later produce brightly coloured berries. *Anthurium* 'Midori' is a Dutch-bred cultivar with a glossy green spathe, up to 16 cm (6 in.) wide. The tip of the spadix appears to have been dipped in green paint, leaving a creamy colour at the base. This plant is an evergreen perennial, originating in the mountainous forests of North and South America.

Care and cultivation

In humid, tropical areas, grow outdoors as epiphytes or in a border. In the growing season, water freely and apply a liquid fertilizer every two to three weeks. Reduce humidity and water sparingly in winter.

In frost-prone areas, anthuriums can be grown in containers or as epiphytes on artificial 'trees' in a warm greenhouse. Indoors, they need humid conditions and a constant temperature with filtered light in summer and full light in winter to thrive. Plant them with their crowns just above the soil surface and keep the uppermost roots from drying out by covering with a layer of moss. Pot on every two years.

Uses

Beyond their usefulness as specimen plants in borders, containers and greenhouses, they also make excellent, long-lasting cut flowers that can last from three weeks to one month in water. Keep the water in the vase fresh by replacing it every three days with cold water. With a sharp knife, re-cut 1 cm (0.5 in.) from the base of each stem under water with each water change.

Other recommendations

Anthurium crystallinum (crystal anthurium): an upright, epiphytic perennial with deep green leaves that are pink-bronze when young. It produces narrow green spathes and yellow-green spadices intermittently throughout the year. Height 60 cm (24 in.).

Anthurium warocqueanum (queen anthurium): a climbing, epiphytic perennial with glossy, emerald-green leaves. Like *A. crystallinum*, it produces narrow green spathes and yellow-green spadices intermittently throughout the year. Height 1.2 m (4 ft.).

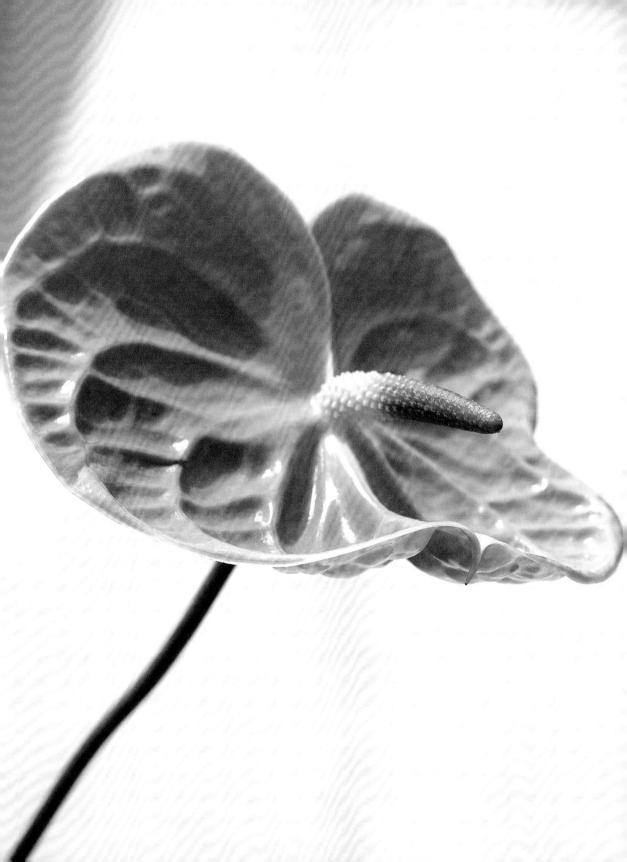

Aquilegia viridiflora
'Chocolate Soldier'

sweet columbine, granny's bonnet

Type of plant
short-lived perennial

Hardiness
USDA Zones 3–10

Position
sun to partial shade

Height
20–30 cm (8–12 in.)

Spread
15–20 cm (6–8 in.)

Aquilegias, often known as sweet columbines or granny's bonnets, are particularly favoured for informal mixed plantings—and the dwarf cultivar *Aquilegia viridiflora* 'Chocolate Soldier' makes a delicate addition to the front of a border. It produces small, upright tufts of lacy foliage, out of which rise purplish flower stems in late spring and early summer. Sometimes these flowers, which have a shy fragrance, stay erect; otherwise, they bend their faces to the ground. At first it may be tempting to dismiss *A. viridiflora* 'Chocolate Soldier' as an odd yet unspectacular plant; however, a closer look reveals an unusual display of long spurs and green sepals, with a central ring of yellow-green-to-bitter-chocolate-coloured petals. It is a plant of quiet appeal, and a humbly winning addition to the garden's green palette.

Care and cultivation

As a short-lived perennial, *Aquilegia viridiflora* 'Chocolate Soldier' may need replacing every few years. All aquilegias self-seed profusely but also hybridize freely, so new plants or seed may be needed to replace exact cultivars. Grow in fertile, preferably moist but well-drained soil in full sun to partial shade.

Uses

This plant will do well in alpine or rock gardens, at the front of a border or on the sunny edge of a woodland garden where drainage is good. The flowers are good for cutting, even though they last only a few days in water; give them a long drink before using in arrangements.

Other recommendations

***Aquilegia vulgaris* 'Lime Sorbet'**: a hardy perennial that produces lime-green to white double pompom flowers without spurs in spring and summer. Enjoys full sun to mostly shady conditions. Much taller than *A. viridiflora* 'Chocolate Soldier', it grows to 1 m (3 ft.).

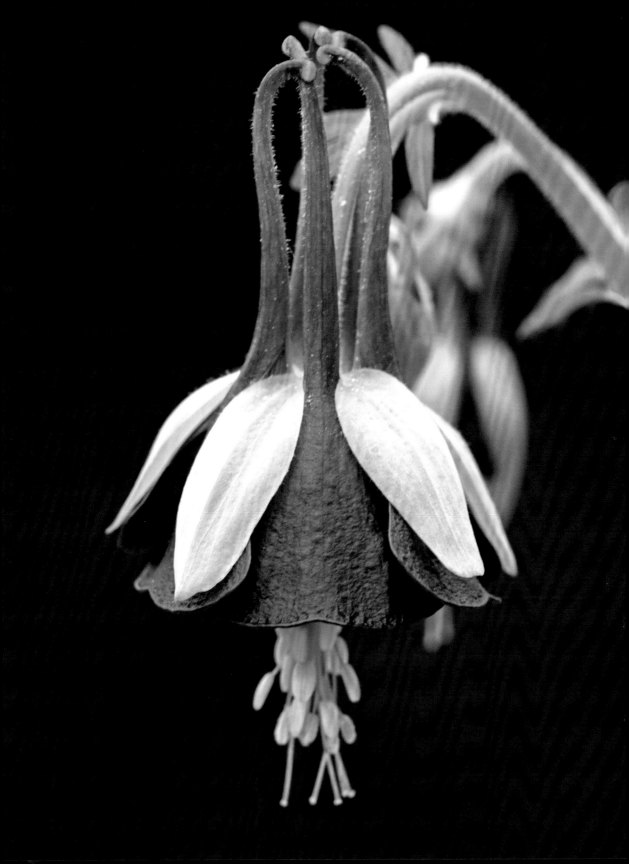

Arisaema jacquemontii

Jack-in-the-pulpit

Type of plant
tuberous perennial

Hardiness
USDA Zones 6–10

Position
sun or partial shade

Height
15–70 cm (6–28 in.)

Spread
10 cm (4 in.)

*Arisaema
triphyllum*

A native of the Himalayas,
Arisaema jacquemontii *can
be found in Kashmir where
its tubers are chopped up
and made into a poultice
for chronic boils.*

What might pass for flowers on arisaemas are actually spathes, or rolled-up leaves, each measuring about 10 to 15 cm (4 to 6 in.) high and resembling a small pulpit, lending the genus its common name of Jack-in-the-pulpit. The spathe of *Arisaema jacquemontii* is narrow and striped white on a pale green background; the tip is elongated and coiled, giving the plant an altogether unique look that is made even more striking when the light filters through the plant's pale stripes. The foliage is distinctive and palm-like, but the real showstopper is the dramatic spadix; in early summer this fleshy flower spike rising from the spathe can be contorted into a long, curving shape. This plant is dioecious and, from fertilized flowers, red berries follow in late summer or early autumn.

Care and cultivation

A typical *Arisaema* species, it likes to be grown out-doors in partial shade, in neutral to acid, moist soil—but is also suitable for a cold greenhouse in frost-prone areas. Outdoors, mulch in winter. Arisaemas grow from tubers that, when dormant, should not dry out completely. They can also be propagated by seed sown in pots in a cold frame in autumn or spring, and they produce offsets which can be transplanted in late summer.

Uses

This plant thrives in moist woodland and looks good on the banks of a shaded stream. Given the right conditions, it also makes a fine specimen plant and talking point in the garden. The unusual form of the plant's spathe is much prized by florists and looks wonderful in contemporary arrangements.

Other recommendations

Arisaema triphyllum: a tuberous perennial, it has a vivid green spathe 10–15 cm (4–6 in.) high which is sometimes striped purplish brown. This appears in late spring to early summer followed by clusters of red berries in autumn. When grown outdoors, leaves must be protected from late frosts. Height 15–60 cm (6–24 in.).

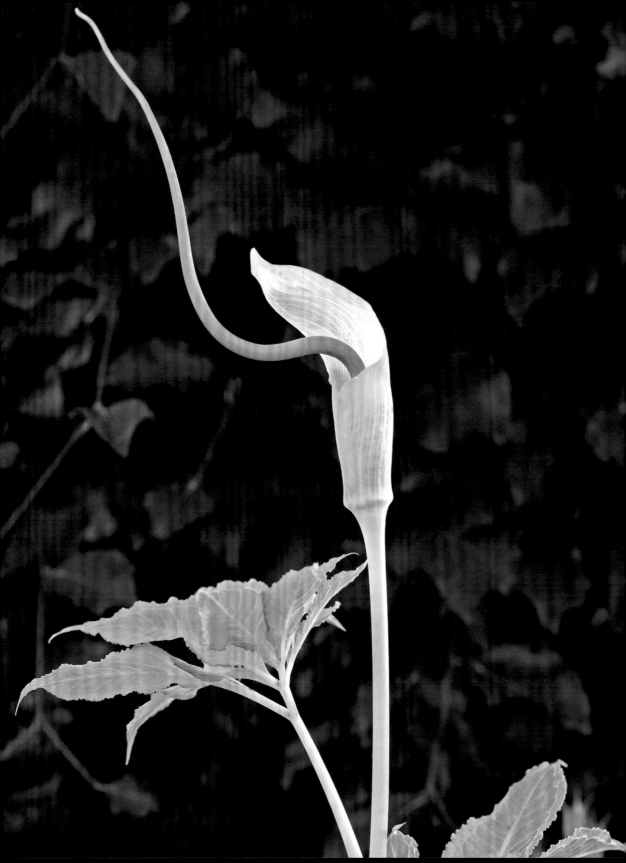

Astrantia major subsp. *involucrata* 'Shaggy'

Type of plant
perennial

Hardiness
USDA Zones 4–9

Position
sun or partial shade

Height
60–100 cm (24–36 in.)

Spread
up to 45 cm (18 in.)

Astrantias are wind resistant, do not need staking, are rarely affected by diseases and do not attract slugs or snails. Too good to be true? Perhaps, as they won't win medals in the scent department; the aroma when in bloom has been described as "disgusting".

This cultivar is thought to have originated in the garden of the famous British plantswoman Margery Fish. A strong plant, it makes a design statement in the garden. The central flowers are white with smaller green to pink florets, but it is the ragged whitish green bracts that catch the eye. They are delicately veined and tipped with a stronger shade of green. After four years this plant is at its best, displaying very large divided leaves on strong upright stems. There is an airy look to this plant, distinct from bushier cultivars. For the first couple of years flowers will be small, but at maturity they can be up to 5 cm (2 in.) across, varying in size on each plant. It is then that they show off the distinctive 'shaggy' habit and become easier to differentiate from the more common *Astrantia involucrata*. The first delicate flush of flowers arrives in late spring, but the full performance happens in early to midsummer.

Care and cultivation

This cultivar prefers fertile, preferably humus-rich, moist but well-drained soil. It thrives when given some shade but also copes with full sun. After flowering, cut the stems down to the ground to ensure more blooms. However, the next display will not be quite as showy. 'Shaggy' spreads easily, so dead-head soon after flowering if self-seeding is not wanted.

Uses

Equally at home in a border, wildflower garden, woodland garden or on a streambank, 'Shaggy' is also a flower-arranger's dream because of its long-lasting character and the fact that it dries well for winter arrangements. Hang upside-down in a cool, dry place for drying. When using fresh flowers, allow them to have a long drink of warm water before arranging.

Other recommendations

Astrantia 'Snow Star': produces cool-looking flowers of white and green. Height 70 m (28 in.).

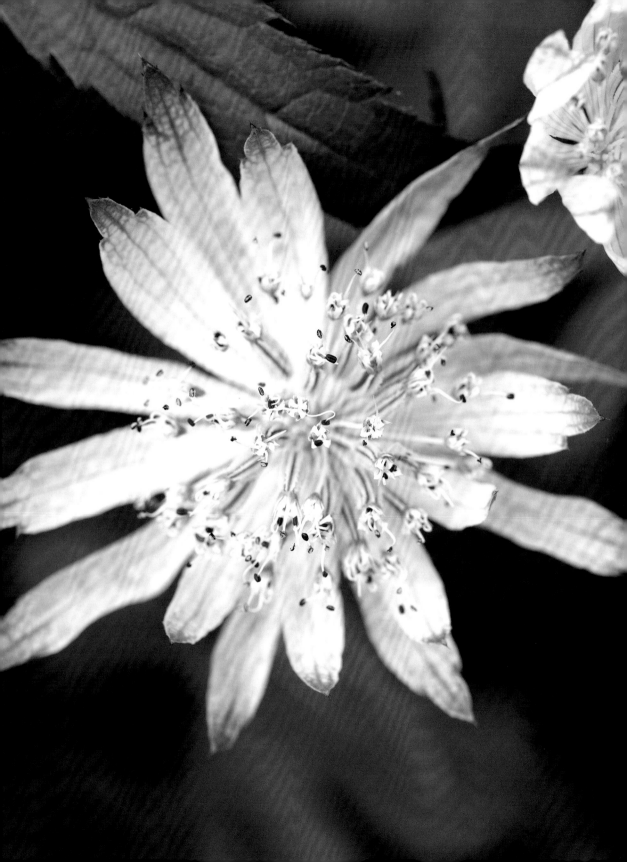

Aucuba japonica 'Crotonifolia'

spotted laurel

Type of plant
shrub

Hardiness
USDA Zones 6–10

Position
sun or partial shade

Height
3 m (10 ft.)

Spread
3 m (10 ft.)

Better known as the spotted or Japanese laurel, this cultivar is dioecious, producing male and female flowers on separate plants. *Aucuba japonica* 'Crotonifolia' is a female plant bearing starry, green flowers in mid spring that blend well with its lime-speckled leaves. After pollination, in autumn, it produces bright red berries. Tolerant of even dry shade, this cultivar will bring a little light into the darkness.

Care and cultivation

Grow in most types of soils (except waterlogged), in sun, partial shade or full shade. (Variegated plants prefer partial shade.) Water well in the growing season, applying a liquid fertilizer monthly, but water sparingly in winter. For *Aucuba japonica* 'Crotonifolia' to produce berries, a male plant must be nearby. Sow seed in containers in a cold frame in autumn, or root semi-ripe cuttings in summer.

Uses

Good as a specimen plant, or for a hedge or screen. It will tolerate slightly hostile conditions like salt spray, pollution, dry conditions and deep shade. However, if sited in a really dark corner, the variegation of the leaves will diminish. Also suitable for containers outdoors and as a large houseplant. The flowers and leaves look marvellous in floral displays.

Other recommendations

Aucuba japonica **'Gold Dust'**: another female plant, with striking leaves speckled golden yellow. Produces red berries in autumn. Height 2–2.6 m (6–8 ft.), and almost as wide.

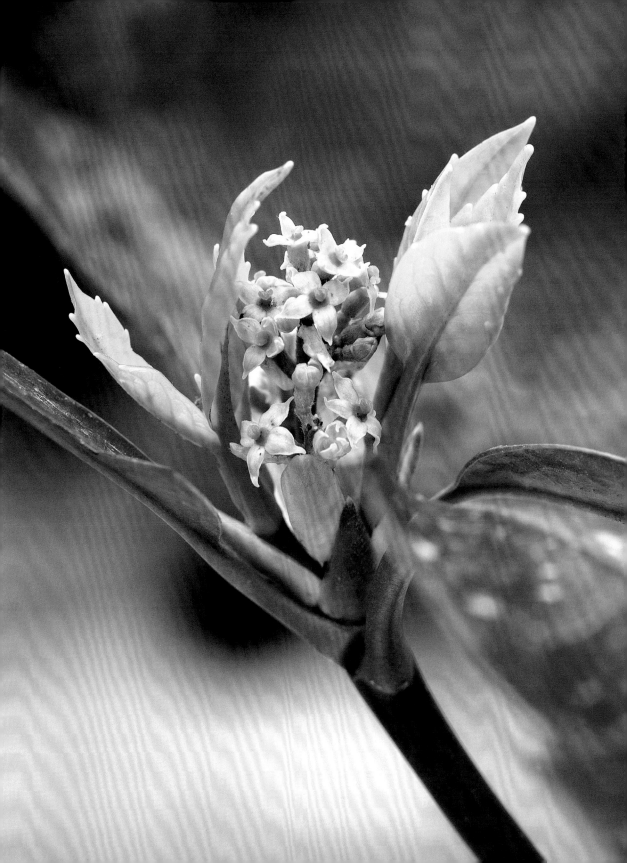

Betula dahurica

Dahurian birch

Type of plant
tree

Hardiness
USDA Zones 5–10

Position
sun or partial shade

Height
up to 20 m (60 ft.)

Spread
10 m (30 ft.)

Birch pollen is thought to be one of the greatest allergens, with fifteen to twenty per cent of hay-fever sufferers having a sensitivity to birch pollen grains.

The genus *Betula* includes about sixty species of trees and shrubs, known commonly as birches, growing in a range of habitats in the northern hemisphere. Birches hybridize freely, but all have interesting bark and an airy open habit which means that the shade they give is not dense. They bear their flowers in long strings, in the form of separate male and female catkins, on the same plant. In the case of *Betula dahurica*, the female catkins are an appetite-enhancing green. These catkins are a firm arrangement of flowers and scales, originally enclosed in buds in winter and expanding with the leaves of the tree in spring. This is a graceful tree, with a straight vertical shape and dark bark.

Care and cultivation
Grow in moderately fertile, moist but well-drained soil in full sun or light dappled shade. Most birches are tolerant of exposed positions.

Uses
As a specimen tree, or in a woodland garden where the shade gives good conditions for planting bulbs and other woodland plants at the base.

Other recommendations
Betula nigra (black birch, river birch): a conical to spreading tree with shaggy, red-brown peeling bark when young. It bears glossy, mid to dark green leaves as well as yellow-brown male catkins and pale yellow-green females in early spring. Height 20 m (60 ft.).
Betula pendula (silver/European white birch, lady of the woods): a narrowly conical tree with peeling white bark and mid-green leaves. It bears yellow-brown male catkins and green female catkins in early spring. Height 25 m (75 ft.).
Betula szechuanica (Szechuan birch): a vigorous, conical tree with chalk-white bark when mature and dark bluish green leaves. It bears yellow-green male catkins and green female catkins to 8 cm (3 in.) long, in early spring. Height 20 m (60 ft.).

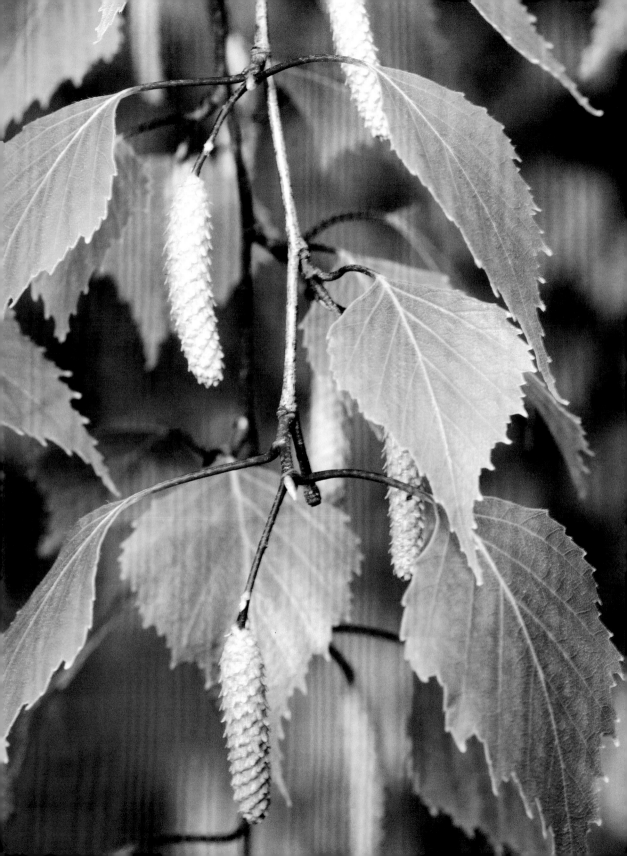

Bryonia dioica

English mandrake

Type of plant
climbing herbaceous perennial

Hardiness
USDA Zones 8–11

Position
sun or shade

Height
2–4 m (6–12 ft.)

Spread
30–38 cm (12–15 in.)

*The bryony root is thigmotropic: it responds to tactile stimulation, or touch, by growing in a particular direction on contact with a physical surface. In medieval times, bryony was often used as a substitute for the much-prized root of the mandrake plant (*Mandragora officinarum*), which was used in all sorts of magical rites. Using the bryony roots' thigmotropic qualities, clever fakers grew them in special moulds to replicate the strange, human-like shape of the mandrake roots.*

A common sight in summer hedgerows, this wild climber is not to be overlooked. The whole plant is a shining bright green, and looks succulent threading in and out of darker hedging. It is dioecious, bearing male and female flowers on different plants—hence the name *dioica*, which literally means 'two dwellings'. The fresh-looking green-white flowers bloom in mid spring; the male blooms are in loose, stalked bunches. From fertile flowers, red berries are produced in late summer and autumn.

Care and cultivation

Grow in any soil, in sun or part shade. This plant looks after itself and is not particularly invasive. Being dioecious, *Bryonia dioica* must have a male plant nearby in order to fruit.

Uses

This plant looks especially attractive when scrambling through hedges, or in a woodland garden. Beware: all parts of *Bryonia dioica* are highly poisonous.

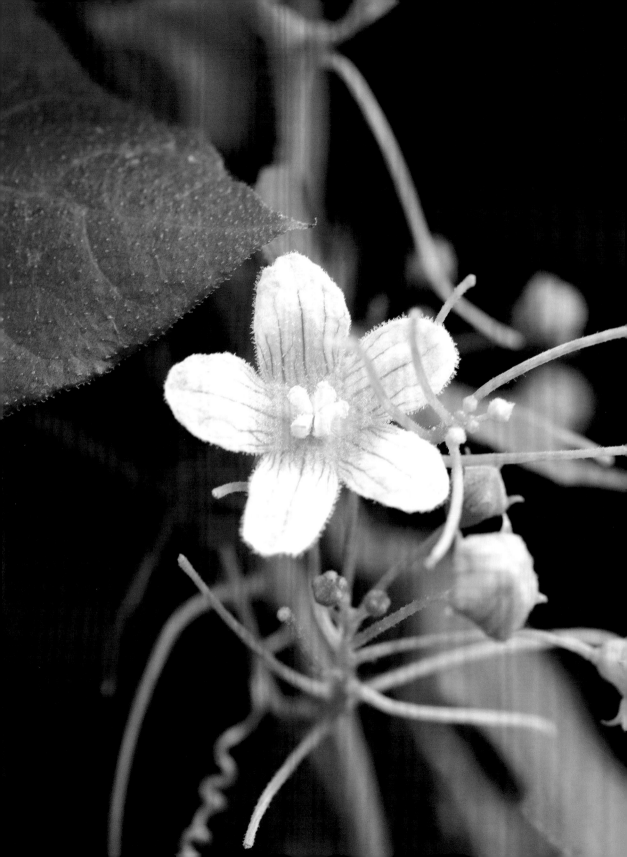

Bupleurum rotundifolium

hare's ear

Type of plant
annual or short-lived perennial

Hardiness
USDA Zones 4–8

Position
sun or partial shade

Height
50–60 cm (20–24 in.)

Spread
30 cm (12 in.)

Bupleurum *specimens contain saikosaponins, which have been found to increase the production of chemicals (known as cytokines) that kindle the combative activity of immune cells. Studies have also suggested that saikosaponins may inhibit the growth of liver cancer cells, and that they have anti-inflammatory properties.*

Bupleurum rotundifolium is marvellous for infilling and brightening up parts of the border, due largely to the striking contrast between its unassuming glaucous leaves and the bright, greenish yellow bracts that surround tiny, star-shaped yellow-green flowers in the summer. Although not of the same family, this bushy plant bears quite a resemblance to some *Euphorbia* species. It is best thought of as an annual, and will seed itself from year to year.

Care and cultivation

Grow in any well-drained soil, preferably in full sun, and dead-head to avoid self-seeding. Sow in situ—it dislikes being transplanted—and keep well watered. When fully established, keep picking the blooms to encourage the plant to become bushier.

Uses

Bupleurum rotundifolium works well in sunny borders and is especially good for cottage-garden-style planting. A favourite of flower-arrangers, it will last up to two weeks in water and provide a relaxed background structure for other blooms.

Other recommendations

Bupleurum angulosum: clump-forming, with streamlined leaves, jade green bracts and creamier flowers than the slightly smaller *B. rotundifolium*. Difficult and slow-growing, it will not tolerate hot summers. Plant in well-drained, uncrowded, sunny site.

Bupleurum fruticosum: a shrub that spreads to 2.5 m (8 ft.) and blooms from midsummer to autumn. The small yellow-green, star-shaped flowers are borne on domed flowerheads. Borderline hardy; good for coastal gardens. Height 2 m (6 ft.).

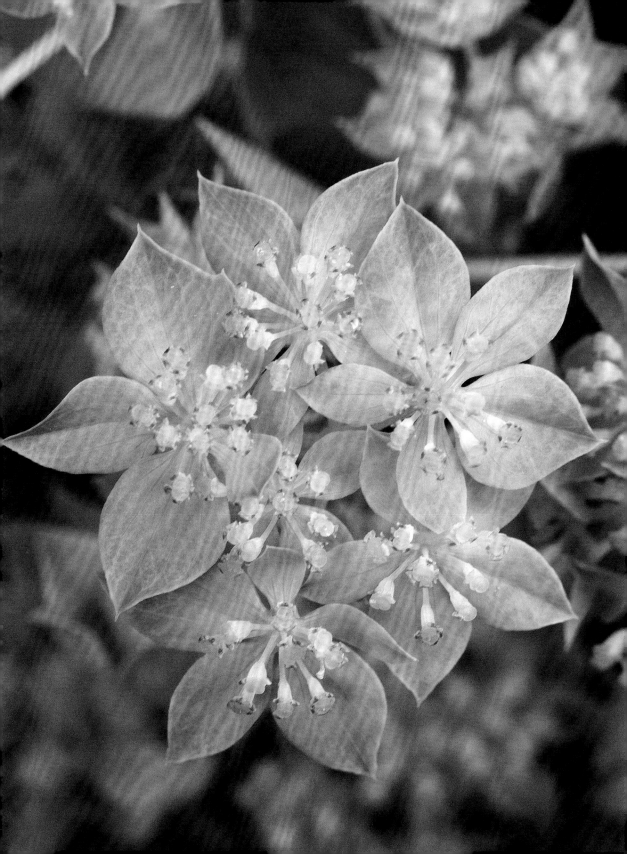

Chiastophyllum oppositifolium

lamb's tail

Type of plant
evergreen perennial

Hardiness
USDA Zones 6–9

Position
partial shade

Height
15–20 cm (6–8 in.)

Spread
15 cm (6 in.)

Once called *Cotyledon simplicifolium*, *Chiastophyllum oppositifolium* is a long name for such a little plant. Barely 15 cm (6 in.) tall, it makes an excellent evergreen ground cover all year. In late spring and early summer it can light up a dry, shaded corner of the garden with its lemony green flowers. The pea-like blooms dangle in graceful chains from erect stems, and the succulent green leaves have scalloped edges. This plant manages well tucked into a dry crevice at the bottom of a wall or in a rock garden. Its habit is to spread by creeping rhizomes, but it is far from invasive.

Care and cultivation
Chiastophyllum oppositifolium is a very accommodating plant that can tolerate a range of different conditions. It is easy to propagate, but the seeds are dustlike and difficult to handle. Ideally it should be grown in moist, well-drained soil in partial shade—but it may also thrive in full sun, depending on the local climate; in grey and moist England, for example, these lemon-lime blooms can be brought out into the open in the summer instead of being relegated to a shady corner.

Uses
In a shady area, in a rock garden or at the base of a wall.

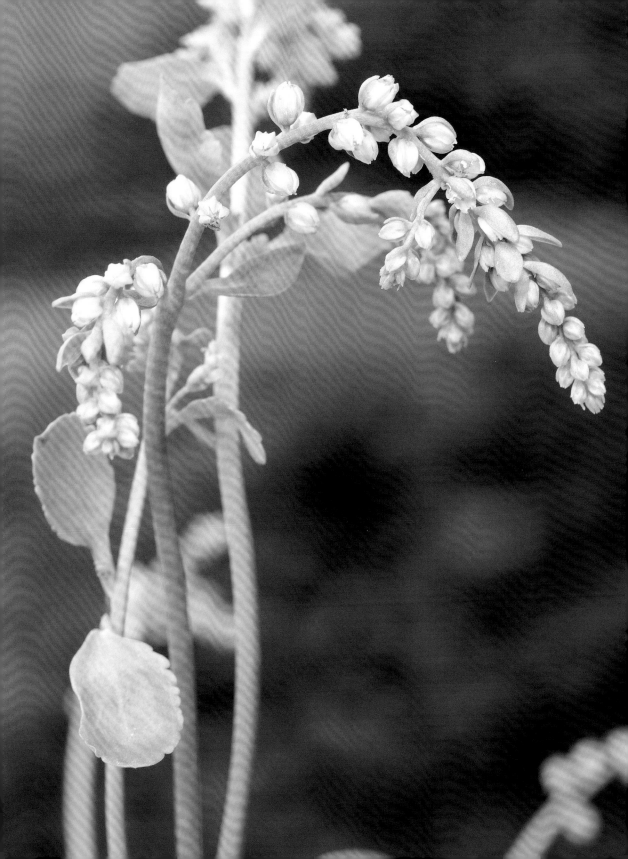

Chrysanthemum 'Shamrock'

Type of plant
perennial

Hardiness
USDA Zones 4–9

Position
greenhouse, or outdoors in light but not full sun

Height
1.2 m (4 ft.)

Spread
40 cm (16 in.)

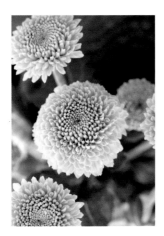

Chrysanthemum
'Feeling Green'

To prepare a flower-feed, add 1 teaspoon sugar (to feed the blooms), 1 teaspoon vinegar (to open the base of the stems, for better water uptake) and a couple of drops of household bleach to 1 litre (2 pints) warm water. Replenish daily.

In this huge genus of popular ornamental flowers, 'Shamrock' has a worthy place. Grown mainly as a florists' chrysanthemum, its spidery, exuberant flowers are a resplendent green—as fresh as sorbet—and grow up to 21 cm (8 in.) across. This chrysanthemum comes into flower in late autumn.

Care and cultivation
Best results will come from greenhouse cultivation, but it can also be used outside as long as there is no frost around. To achieve a dramatic form, it is best to grow the plants as sprays: do not remove any buds during growth.

Uses
In a greenhouse display or as a patio flower in summer. It is a great flower for cutting, as it is long lasting. Strip off the bottom foliage before giving the plant a long drink prior to arranging.

Other recommendations
Chrysanthemum **'Feeling Green'**: produces pale green, pompom-like flowers about 4 cm (1.6 in.) across. For greenhouse cultivation.

Chrysanthemum **'Green Nightingale'**: spider-type flowers with bright green centres and very long, green-tipped white outer petals; similar to 'Shamrock', but even wilder in form. Quite tough and easy to grow in the greenhouse. Produces stunning displays as blooms, or sprays if all buds are left on. Flowers mid to late autumn.

Chrysanthemum **'Osorno'**: green spray chrysanthemum with pale green, slightly grey petals. The heart of the flower is bright green, and the overall effect is a very contemporary colour combination. Fairly flat flowerhead and strong leaves. Very long vase life. Cultivate in the greenhouse.

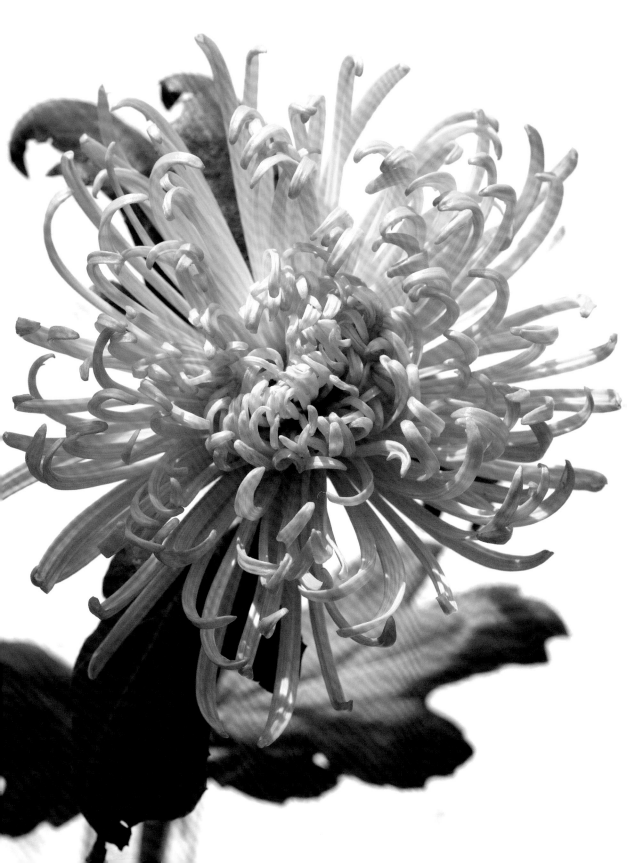

Clematis florida 'Plena'

Type of plant
perennial deciduous climber

Hardiness
USDA Zones 7–9

Position
full sun

Height
2.4 m (8 ft.)

Spread
1 m (3 ft.)

This interesting cultivar is derived from the Chinese species, *Clematis florida*. Green buds open to creamier flowers; the light green tinge at the heart of its blooms recalls the soft tones of celadon glaze. Flowers are large (up to 10 cm [4 in.] across), abundant and double. The deciduous plants enjoy a sunny, sheltered border and also look luxuriant in containers. The flowering vines scramble high up to easily cover trellises, porches and arbours, pergolas and posts. Flowering goes on from early summer to early autumn.

Care and cultivation
This clematis prefers fertile, humus-rich soil in a sunny, well-drained location; keep roots mulched or shaded. Like all climbing clematis, it should be planted with the top of its root ball about 8 cm (3 in.) below the soil surface, to reduce the risk of clematis wilt. Mulch in late winter with garden compost or well-rotted manure, avoiding the plant's immediate crown.

Uses
Works well in borders, containers, pergolas, trellises and patios and is also attractive grown through shrubs or over small trees, to show off masses of large double blooms.

Produces fantastic cut flowers, although clematis have short flower stems; cut boughs, or—if using in a short-lived bouquet—use florists' wire to elongate stems (blooms will not last all day without water). Seedheads can be used in winter arrangements.

Other recommendations
Clematis florida **var.** *flore-pleno*: a deciduous or semi-evergreen, mid-season- to late-flowering, large-flowered climber that produces double, greenish white flowers in late spring and summer. Height 4 m (12 ft.).
Clematis **'Pixie'**: a compact evergreen clematis, ideal where space is limited. Sweetly scented lime-yellow flowers in spring. Hardy to –5°c (23°F). Thrives in a sunny sheltered spot in well-drained soil. Height 1.2 m (4 ft.).

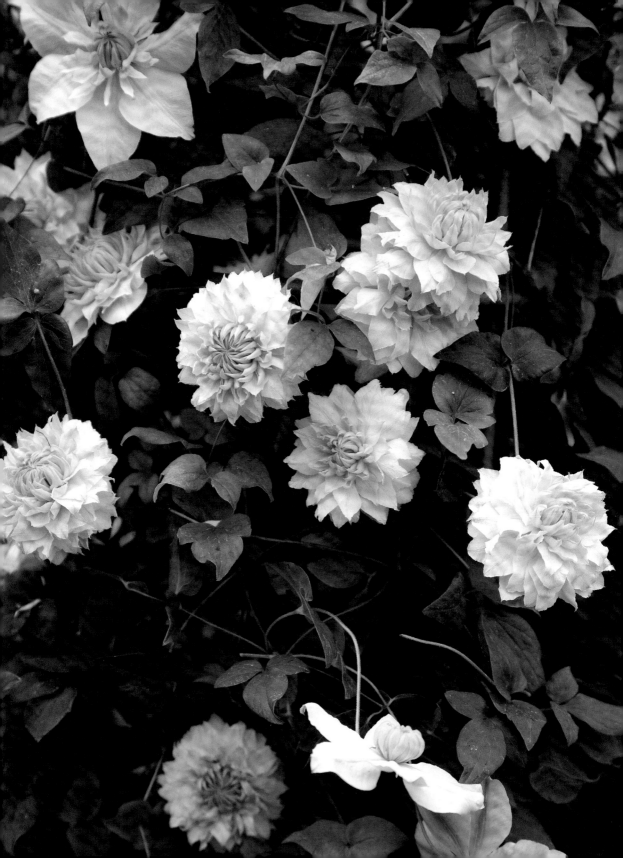

Codonopsis tangshen

bellflower, false ginseng

Type of plant
perennial herbaceous climber

Hardiness
USDA Zone 4–10

Position
sun or partial shade

Height
2 m (6 ft.)

Spread
60 cm (24 in.)

The foliage of Codonopsis tangshen *can have a rather disarming 'foxy' smell, but this is worth disregarding for the unusual delicacy of the blooms.*

Codonopsis tangshen is one of about thirty species of *Codonopsis*—better known as bellflowers or false ginsengs—that twine or climb as they grow. They are mostly herbaceous perennials originating on rocky mountain slopes. The flowers of *C. tangshen* are nodding-bell-shaped and delicately veined with soft purple. The pale olive-green flower is usually borne on its own rather than in a cluster, but it fuses gently with the pointed leaves, standing out by virtue of its shape, translucency and distinctive marking.

Care and cultivation

Grow in light, fertile, humus-rich, moist but well-drained soil, in sun or partial shade, with shelter from strong winds to protect the slender, brittle shoots. Provide twiggy support. In very cold areas, mulch in winter. This plant is frost-tender.

Uses

Grow in a herbaceous border or woodland garden. It looks particularly good twining through small shrubs.

Other recommendations

Codonopsis clematidea: has twining, grey-green leaves on branching stems, and solitary, nodding, bell-shaped, pale greenish blue flowers with yellow, blue and black markings inside, in late summer. Height to 1.5 m (5 ft.).

Codonopsis lanceolata (bonnet bellflower): has twining purple-tinged stems and mid-green leaves. Solitary or paired pendent, bell-shaped, greenish white flowers, spotted and striped violet inside, are produced in autumn. Height 60–90 cm (24–36 in.).

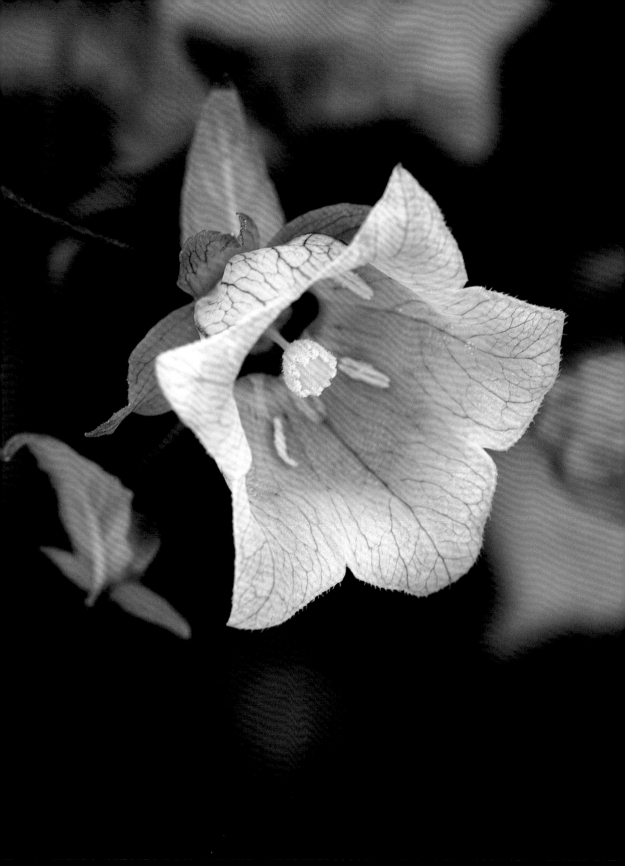

Cornus kousa

Kousa dogwood

Type of plant
tree

Hardiness
USDA Zones 5–8

Position
sun or partial shade

Height
up to 7 m (21 ft.)

Spread
up to 5 m (15 ft.)

The common name for Cornus *is dogwood. One explanation for this epithet is that an astringent liquid made from steeping the bark was used to wash dogs suffering from mange. However, a more likely derivation is from 'daggerwood', referring to the practice of using sticks as skewers for meat.*

The genus *Cornus* encompasses around forty-five species, mainly deciduous shrubs with a few small trees and some woody perennials. *Cornus kousa* is a medium-sized deciduous tree with a conical habit, well worth growing for the surprising green blooms it produces in early summer. These 'blossoms' are in fact clusters of tiny mid-green flowers surrounded by four papery bracts, each up to 6 cm (2.5 in.) long, that are each teardrop-shaped. When the blooms are covering the tree, their bold shape and white-green freshness creates a surprisingly exotic look. As an added bonus, *C. kousa* has interesting flaking bark and produces juicy-looking (yet non-edible) red fruits after flowering. The autumn foliage, coloured a warming and intense red-purple, is particularly cheering as the winter creeps in.

Care and cultivation
This tree thrives in humus-rich, well-drained, neutral to acid soil in sun or partial shade.

Uses
A very effective specimen tree, especially in a woodland garden.

Other recommendations
Cornus kousa var. *chinensis*: has large, tapered bracts, to 5 cm (2 in.) long, which begin a soft vellum-white before turning to bright white and eventually reddish pink. Produces green flowers similar to those of the species. Height to 6 m (18 ft.).

Cornus kousa 'Satomi': produces green flowers similar to those of *C. kousa*, with dark red-purple autumn foliage and dark pink bracts. Height to 3 m (9 ft.).

Cornus kousa 'Schmetterling': rather similar to the species, it produces distinctive green-tinted white bracts. Height 4.5–9 m (14–27 ft.).

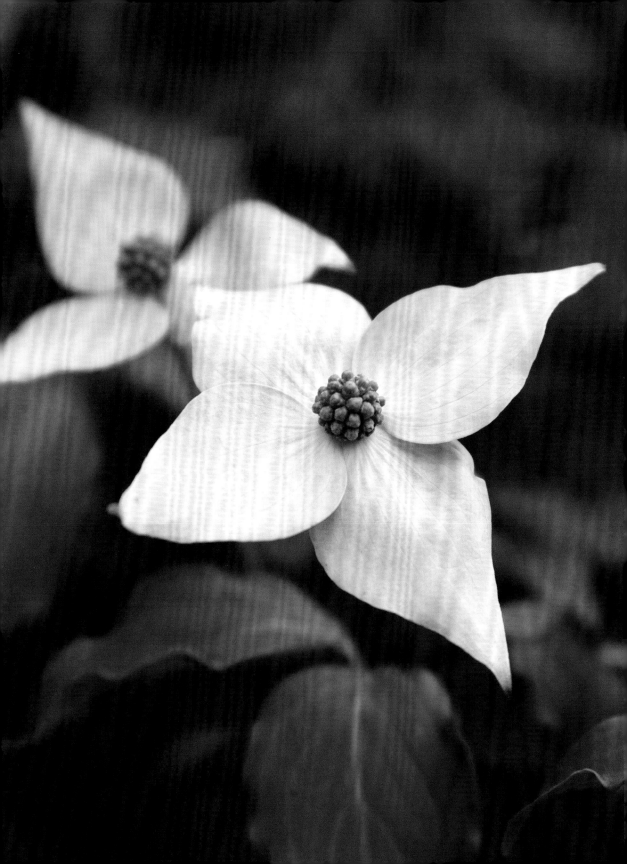

Correa reflexa 'Fat Fred'

Type of plant
exotic shrub

Hardiness
USDA Zones 8–10

Position
sun

Height
30 cm–3 m (1–10 ft.)

Spread
1–3 m (3–10 ft.)

While the genus *Correa* encompasses a variety of evergreen shrubs and small trees found throughout most of Australasia, this green form is cultivated as a greenhouse specimen in frost-prone climates. Its leaves are usually covered with star-shaped hairs and become aromatic when bruised. The flowers are a soft green with a downy texture. They are gently pendent and appear in small clusters, mainly from autumn to spring. Whereas the flowers of the species *C. reflexa* are entirely green, the cultivar 'Fat Fred' has wide bell-shaped flowers flushed red-pink; the green tips show up more boldly against this complementary colour.

Care and cultivation

In a greenhouse, grow in lime-free potting compost in full light and with good ventilation, shaded from hot sun. Water moderately and apply liquid fertilizer monthly in the growing season; water sparingly in winter.

Outdoors, grow in fertile, moist but well-drained, neutral to acid soil in full sun. This plant tolerates mildly alkaline soil and salt spray. Prune tips after flowering to encourage compact growth.

Uses

In frost-prone climates, grow in a cool greenhouse or conservatory; in warmer areas, grow in a shrub border or sheltered garden, or near the house wall. Prostrate varieties are ideal for rockeries or for use as ground cover. A good decorative pot plant when sited in a light position, it can also make an unusual cut flower.

Other recommendations

Correa backhouseana: a dense, spreading shrub producing small clusters of tubular, pale or reddish green or cream flowers from late autumn to late spring. Height 1–2 m (3–6 ft.).

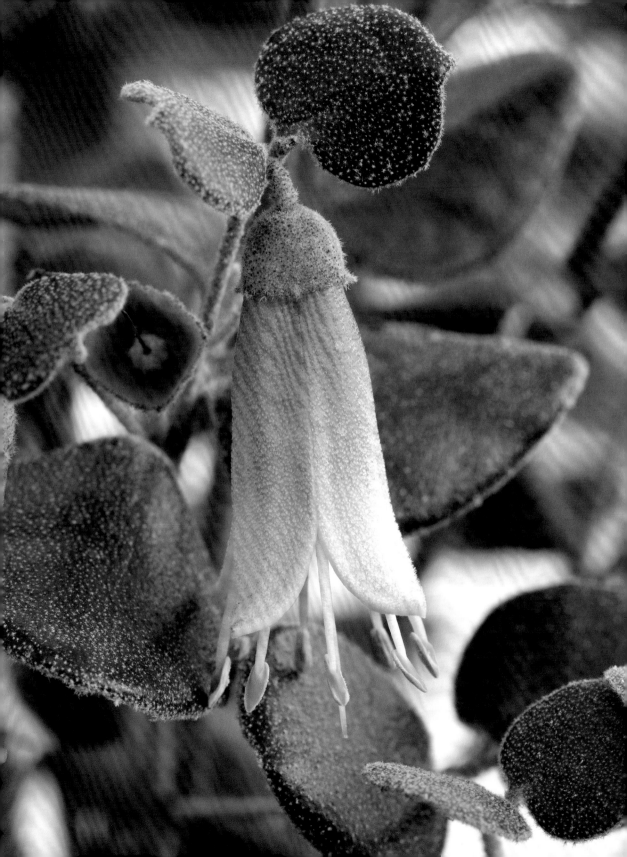

Crotalaria laburnifolia
bird flower

Type of plant
perennial evergreen shrub

Hardiness
USDA Zones 9–11

Position
sun

Height
up to 2 m (6 ft.)

Spread
2–3 m (4–6 ft.)

While researching this plant, I discovered that the specimen now living in the Economic Botany Collection in Kew Gardens, England, originated in India and was donated to the collection by HRH The Prince of Wales.

Crotalarias are sometimes called rattle-boxes, thanks to the ripe seeds that rattle around loosely in their inflated pods. The bright yellow flowers of *Crotalaria laburnifolia*, or bird flower, have light green keels, or scoop-shaped structures at the bottoms of the flowers, each comprised of two petals growing together. The blooms, which arrive in summer and autumn, are followed by pendulous seed pods that can be mottled with red-brown. Native to Africa and Central America, *C. laburnifolia* thrives in southern California and hot mediterranean climates.

Care and cultivation
Outdoors, grow *Crotalaria laburnifolia* in fertile, moist but well-drained soil—and, being frost-tender, it enjoys full sun. Outdoors, prune lightly to encourage repeat flowering and accentuate the plant's natural shape. In frost-prone areas, grow in a temperate greenhouse in loam-based potting compost, in full light but shaded from the hot sun and with good ventilation.

Uses
In warm, dry climates, grow against a warm, sunny wall. It also works well in a border, making an especially striking statement when mixed with purple foliage or flowers.

Other recommendations
Crotalaria agatiflora (canary-bird bush): an erect to spreading shrub with mid- to deep green leaflets. Yellow-green to olive-green flowers arrive in summer, followed by large rattle-like seed pods. Height 2–3 m (6–10 ft.).

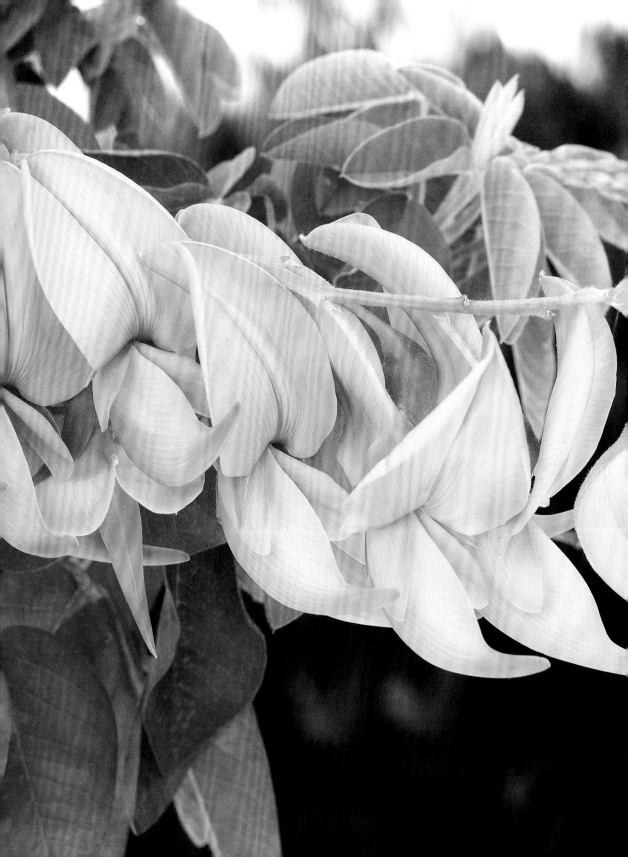

Cyperus papyrus 'Nanus'

dwarf papyrus

Type of plant
evergreen perennial

Hardiness
USDA Zones 8–10

Position
full sun to partial shade

Height
up to 60 cm (24 in.)

Spread
60–100 cm (24–36 in.)

The widespread sedge family, Cyperaceae, includes more than 3,500 species growing on all continents except Antarctica. Most are wetland plants, and only a few are cultivated as ornamentals. Cyperus papyrus *is the famous papyrus plant, or Egyptian paper rush;* C. papyrus *'Nanus' is its dwarf form.*

Here is a sedge with an edge: a mixture of architectural shape and water-green shades makes *Cyperus papyrus* 'Nanus' an indoor plant with contemporary style. From a sheath of thin leaves, the tiny, pale-green inflorescences spurt from spoke-like darker green stems. In warmer areas it can be grown outside as a pond marginal, where it enjoys sun or partial shade.

Care and cultivation

This frost-tender plant has very high moisture needs and is suitable for bogs and water gardens. The soil must be consistently moist, so do not allow it to dry out. Propagate by dividing the rhizomes, tubers, corms or bulbs (including offsets). Sow seed indoors before the last frost. It self-sows freely.

Uses

Cyperus papyrus 'Nanus' is used as a pool ornamental in warm areas or in conservatories. It is sometimes potted and grown indoors. The attractive stems are good for structure in flower arrangements. Flower-heads can be dried by hanging them upside-down in a cool, dry place.

Other recommendations

Cyperus albostriatus (dwarf umbrella plant): worth growing for its lime-green autumn foliage. Bears pale greenish yellow spikes of flowers midsummer to early autumn. It will happily grow in a cold climate to −1°C (30°F). Height 60 cm (24 in.).

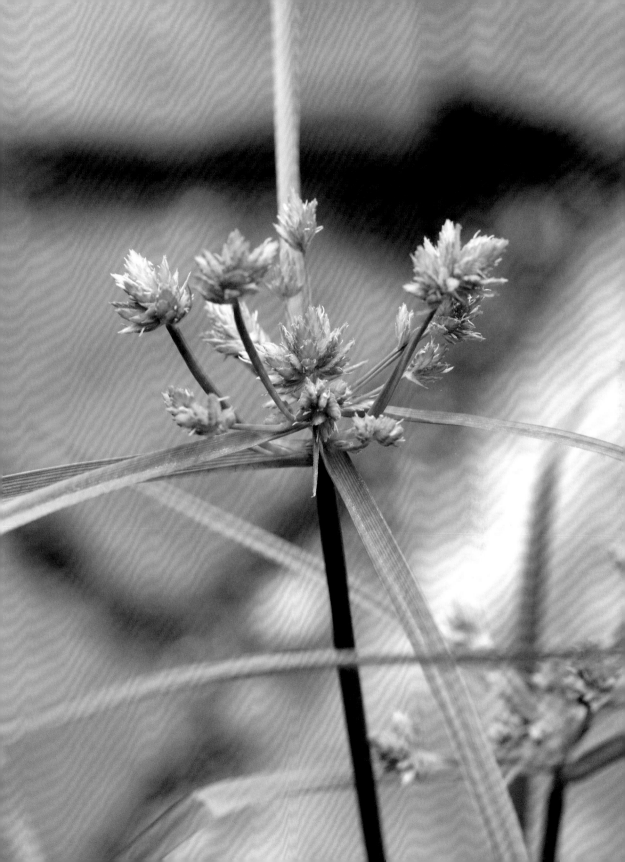

Daphne laureola

Type of plant
evergreen shrub

Hardiness
USDA Zones 6–10

Position
sun or partial shade

Height
1 m (3 ft.)

Spread
1.5 m (4.5 ft.)

*Daphne
pontica*

Fragrance is the main attraction of the evergreen *Daphne laureola*. Up to ten pairs of pale green flowers, often infused with yellow, cluster on the end of the stems, filling the air with sweet scent in late winter and early spring. The tiny, tubular flowers, nestling among glossy dark green leaves, are an early attraction for humans and insects alike. Black and berry-like fruit follows later, but beware as it is poisonous.

Care and cultivation

Because daphnes like to keep cool roots, mulch should be applied at their base to keep the sun off. Grow in humus-rich, well-drained but not dry soil; they are happy with moderate fertility. Most daphnes prefer slightly alkaline to slightly acid soil in sun or partial shade, and *D. pontica* likes cool shade and tolerates deep shade. All daphnes dislike being transplanted. Prune minimally.

Uses

Grow in a shrub border, a rock garden, or woodland. This plant is also a delight to have perfuming the house early in the year; a few sprigs in a bedroom can scent the room for weeks. All parts, including the seed, are highly toxic if eaten and the sap may cause skin irritation.

Other recommendations

Daphne laureola subsp. **philippi**: has a compact, semi-prostrate habit with slightly smaller leaves and fragrant flowers. Height 45 cm (18 in.).
Daphne pontica: a spreading evergreen shrub with pointed, glossy, dark green leaves. Flowers later than *D. laureola* in mid to late spring. Has clusters of fragrant, yellow-green flowers that are larger than those of *D. laureola*. Black fruit. Height 1 m (3 ft.).

In Greek mythology, Daphne was a dryad—a spiritual being who lived in trees and forests—and daughter of the river god Peneus. Apollo fell in love with her, but Eros shot Daphne with an arrow so she could never return this love. To protect his daughter from the amorous intentions of Apollo, Peneus turned Daphne into a laurel tree.

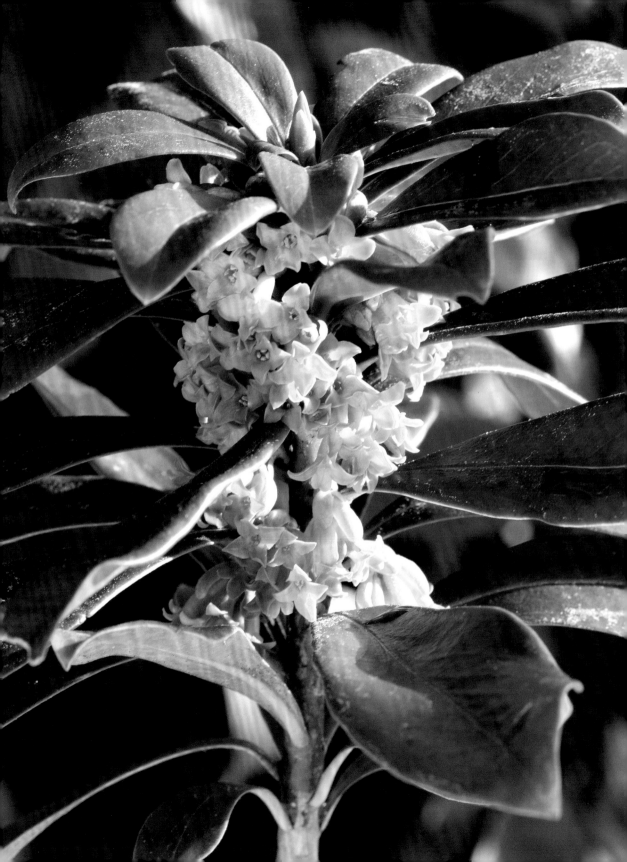

Dianthus carophyllus 'Prado'

carnation

Type of plant
perennial

Hardiness
USDA Zones 6–9

Position
greenhouse, or sun outdoors

Height
up to 30 cm (12 in.)

Spread
8 cm (3 in.)

The name Dianthus *was given by the Greek botanist Theopharastus (born 370* BC)*, who combined the words* dios *and* anthos *to convey 'flower of god'. Later, Christianity took up the theme and, according to Christian legend, carnations first appeared on earth as Jesus carried his cross; the flowers sprang up from the ground where the tears of the grieving Virgin Mary fell.*

Among tens of thousands of *Dianthus* cultivars, this one stands out as a favoured florists' carnation. *Dianthus carophyllus* 'Prado' is considered to be a 'perpetual flowering' carnation, which means it is half hardy and usually grown under glass. It has a flowerhead of tightly packed pale green petals gathered together in ruffles; however, it is quite unstable in form and these flowers can range from rather formal-looking to altogether relaxed. In both cases, the pale green makes a wonderful foil to pink or red carnations and it blooms over a long period in the greenhouse, probably from early summer to mid autumn. The foliage is blue-green and delicately lance-shaped.

Care and cultivation

Plants only grow true to form from cuttings and are usually purchased from specialist nurseries. Pot into 9-cm (3.5-in.) pots in a multi-purpose compost, sharp sand and vermiculite mix. Do not plant too deeply and pot on as the roots enlarge. 'Perpetual flowering' forms of *Dianthus* require 'stopping', in which the growing tip is removed to encourage flowering side-shoots to develop. Support plants with a cane. For all-year-round flowering, a minimum temperature of 15°C (59°F) is required. Ventilate the greenhouse well and use shading in summer months.

Uses

This cultivar can be planted out in borders after the risk of frost has gone but is better as a container or greenhouse specimen. Its best use is as a cut flower; strip off some of the foliage, trim the bottom of stems and give a long drink before arranging. All parts of the plant are poisonous if ingested.

Other recommendations

Dianthus **'Musgrave's Pink'** (syn. *D.* 'Charles Musgrave', *D.* 'Green Eyes'): a bicolour, old-fashioned pink producing clove-scented, single white flowers with green eyes. It has been grown since 1730. Height 15–30 cm (6–12 in.).

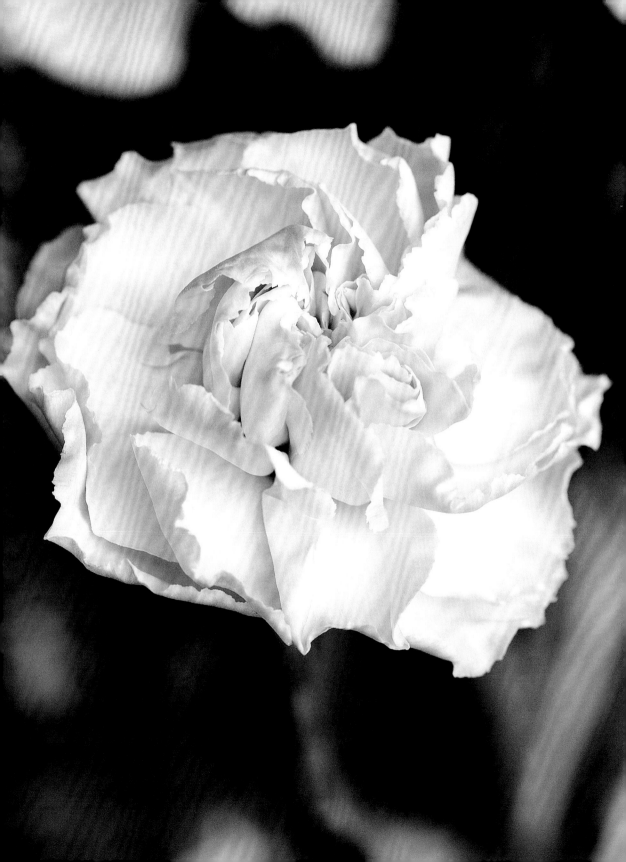

Digitalis grandiflora

yellow foxglove

Type of plant
perennial

Hardiness
USDA Zones 3–8

Position
partial shade

Height
60–100 cm (24–40 in.)

Spread
50 cm (20 in.)

Digitalis *means 'digit' or 'finger' in Latin, and the Germans call the foxglove* fingerhut, *which means 'thimble', or literally 'finger hat'. Foxes are notoriously stealthy killers, often leaving no trace of their slaughter—and it was once believed that foxes put the cap-like flowers of digitalis on their feet to obscure their footprints when raiding chicken coops.*

Digitalis grandiflora, often known as the yellow foxglove, deserves a place in these pages as its pale yellow flowers are tinged green when they first arrive in late spring. When planted among other greenery they are at home in the verdure, taking on some of the tint of green. Their colour blends well with other hot or cool hues in the garden, and blooming can continue into early autumn. Smaller and finer than the common purple foxglove, it has delicate tapered and pleated leaves. Like all foxgloves, it tolerates a wide range of conditions but, in hot areas, thrives better with a little shade.

Care and cultivation

This plant can self-seed profusely, so dead-head after flowering unless seedlings are required. It may be encouraged to bloom again in the same year if cut back after flowering. Grow in almost any soil and situation, except very wet or very dry, although it prefers humus-rich soil in partial shade.

Uses

Suitable for naturalizing in woodland or a border, it is especially useful where a vertical design emphasis is needed.

Digitalis grandiflora is long-lasting in flower arrangements. After cutting, put in a deep container of warm water and leave several hours before arranging. Lower flowers may be removed if they drop before top buds have developed. Contact with foliage may irritate skin. Above all, take care not to ingest.

Other recommendations

Digitalis viridiflora: a perennial with a dense habit, enjoying partial shade. It has a dull greenish yellow flower, conspicuously veined, that makes a long-lasting cut flower. Height 50–80 cm (20–32 in.).

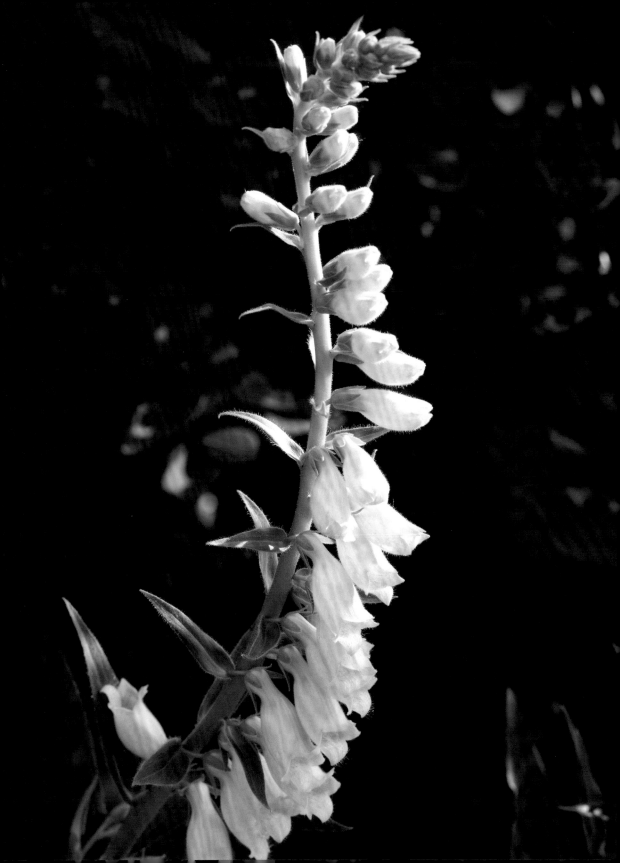

Dipsacus fullonum
common teasel

Type of plant
biennial or short-lived perennial

Hardiness
USDA Zones 3–8

Position
sun or partial shade

Height
1.5–2 m (5–6 ft.)

Spread
30–80 cm (12–32 in.)

Teasels are very important to the textile industry even in the present day: through a scouring action, the dried flowerheads of Dipsacus fullonum *are able to create a polished lustre on many high-quality cloths. Efforts have been made to develop a synthetic alternative to teasels, but even the finest wire brushes are too severe in their action. The British textile industry alone uses fourteen million teasels each year.*

This prickly plant has a distinctive, architectural shape. The impressive sculptural foliage of *Dipsacus fullonum* springs from erect stems, and its symmetrical habit makes it look almost military. In the plant's 'green stage' in midsummer, its thistle-like head has a silvery tinge and thereafter produces minute flowers. Being biennial, the leaves begin as rosettes on the ground in the first year; in the second summer, the plant will grow to over 1.5 m (5 ft.), with dark green spiny leaves. Flowering seedheads then branch from the rigid, prickly main stem, lasting for about three weeks. When the cone-shaped 3–8-cm (1.25–3-in.) long flowers have faded in mid to late summer, they can be harvested for drying. In the wild, teasels are often found next to sheep pastures.

Care and cultivation
Grow in any moderately fertile soil, including heavy clay, in sun or partial shade. Sow seed directly where they are to grow in spring.

Uses
Grow in a wild garden or informal border, or use as punctuation marks among grasses such as *Stipa tenuissima* and pennisetums. The architectural habit of this plant makes it good for flower arrangements. Its distinctive flowerheads can be used when fresh, but also dry well; strip stems of foliage and harvest heads for air-drying when their tiny flowers have faded.

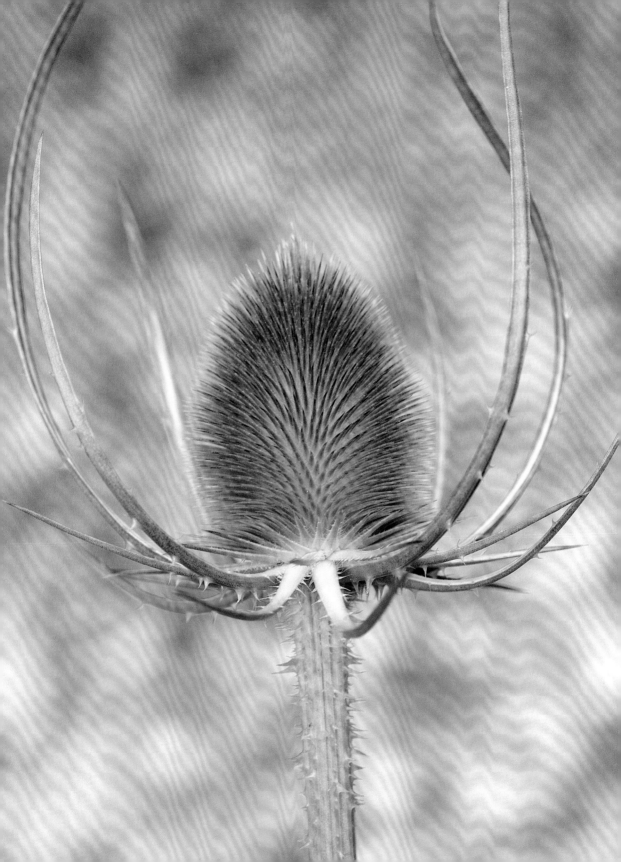

Disporum hookeri

fairy bells

Type of plant
rhizomatous perennial

Hardiness
USDA Zones 4–8

Position
partial shade to full shade

Height
1 m (3 ft.)

Spread
50 cm (20 in.) or more

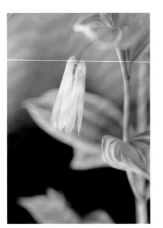

Disporum sessile 'Variegatum'

Disporum hookeri is a woodland plant of great charm, native to the United States. In late spring, slender arching stems support flowers that are a gentle greenish cream colour. Following later, in early autumn, there are black berries. This dainty plant—named fairy bells because of the tubular bell shape of its flowers—is fresh, bright and vigorous when thriving. The deep green foliage is almost leathery, and scored with parallel grooves that allow water to run down their channels and drip gracefully from the sharply pointed tips of the leaves.

Care and cultivation

Plant 7.5 cm (3 in.) deep in humus-rich soil in a partially or fully shady position, about 30 cm (12 in.) apart. *Disporum hookeri* spreads through underground rhizomes, so may be divided. Alternatively, sow seed directly where it is to grow in autumn. It may take time to get its roots down, but this plant repays patience.

Uses

Grow in a woodland garden or on a peat bank. The flower and foliage of *Disporum hookeri* both work well in wildflower arrangements.

Other recommendations

Disporum lanuginosum: a clump-forming, rhizomatous perennial. Trumpet-shaped, pale yellowish white or greenish white flowers arrive in late spring and black or red berries in early autumn. Height 30–90 cm (12–35 in.).

Disporum sessile **'Variegatum'**: a clump-forming, rhizomatous perennial with pendent tubular cream flowers tipped with green, white and green-striped foliage. It flowers in late spring, and produces orange-red berries in early autumn. Height to 45 cm (18 in.).

Disporum smithii: a clump-forming, rhizomatous perennial that tolerates deep shade. It has pendent, tubular-bell-shaped, greenish white flowers in early to late spring and orange berries in late summer. Height 30–90 cm (12–35 in.).

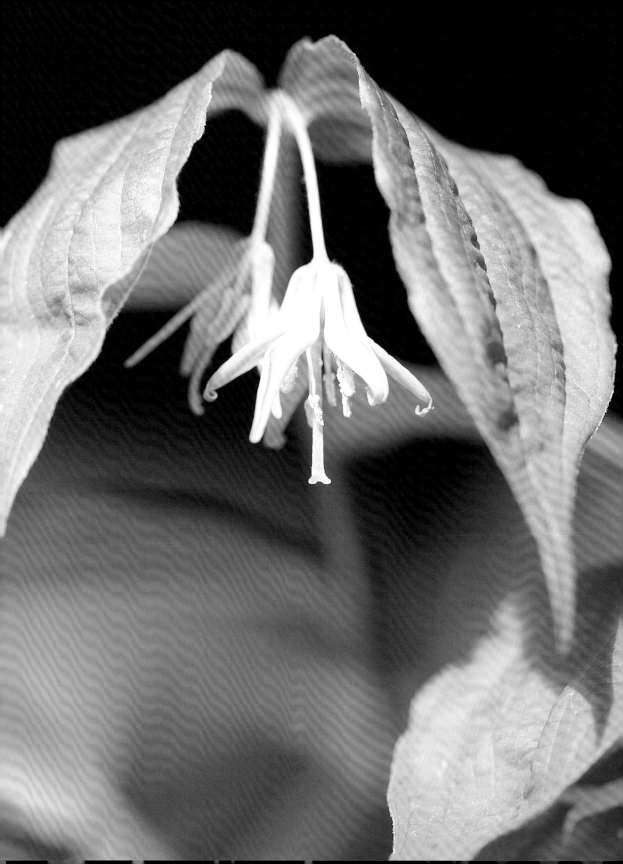

Echinops sphaerocephalus
globe thistle

Type of plant
herbaceous perennial

Hardiness
USDA Zones 3–10

Position
sun or partial shade

Height
2 m (6 ft.)

Spread
just under 1 m (3 ft.)

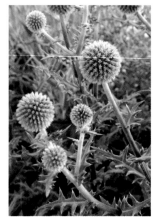

*Echinops
sphaerocephalus
'Arctic Glow'*

The name Echinops *derives
from the Greek* echinos*,
which means 'hedgehog'—
a fitting reference to the
flowerhead's prickliness.*

Easy and undemanding, this *Echinops* species is used to living on hot, stony hillsides and dry grassland, so it responds happily to any care in a garden—just don't be *too* good to it! The genus *Echinops* goes by the common name of globe thistle, referring to the satisfyingly round shape of the prickled flowerheads. In high summer *E. sphaerocephalus* has heads borne on long silver-green stems, and its spiny foliage has whitish, hairy undersides. Just before it reaches its full flowering the globe goes through an 'unripe' darker green stage, transforming to a silvery green. The play of light and shade on this spherical flower creates sculptural interest in a border; it works with both traditional and modern planting styles. Self-seeding profusely, it tends to pop up in areas that would appear totally inhospitable to other plants.

Care and cultivation
Best grown in poor, well-drained soil in full sun; will grow in almost any soil in full sun or partial shade. When the root is established it is drought tolerant. Dead-head to prevent self-seeding and cut right back in autumn. It rarely needs division but if necessary, divide in mid to late autumn.

Uses
Undemanding and suitable for a large border or wild garden, *Echinops sphaerocephalus* associates well with cardoons, echinaceas and tall miscanthus grasses. It is excellent for cutting and drying: strip off prickly lower leaves and hang upside-down in cool, airy place. (If dried during the green stage, the green colour may fade.)

Other recommendations
***Echinops sphaerocephalus* 'Arctic Glow'**: slightly smaller and less robust than the species. Stems are flushed red. Height 1.5 m (5 ft.).

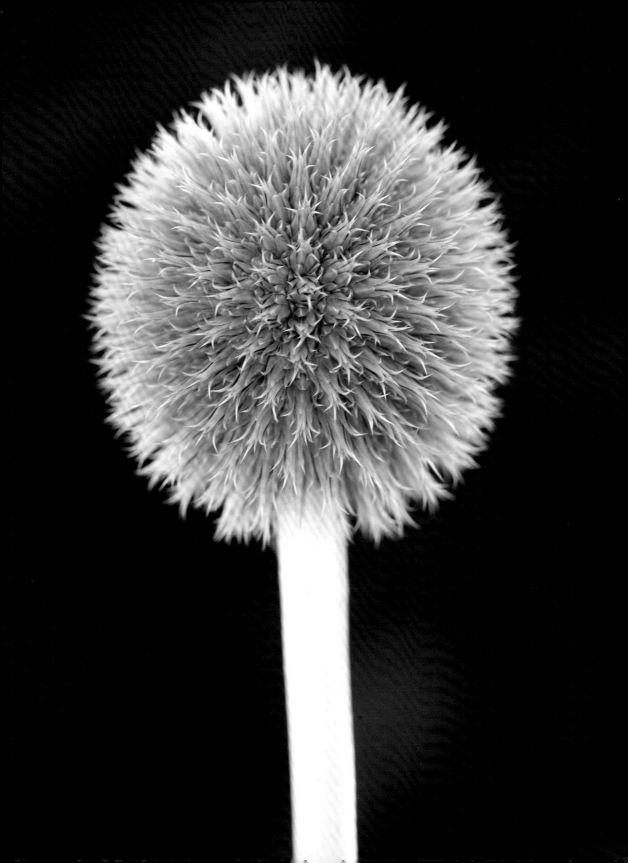

Eryngium variifolium

Moroccan sea holly

Type of plant
evergreen perennial

Hardiness
USDA Zones 4–10

Position
sun

Height
30–40 cm (12–16 in.)

Spread
25 cm (10 in.)

*Eryngium
agavifolium*

*The cultivar 'Miss
Willmott's Ghost' was
named after Ellen
Willmott, an eccentric
English gardener who
would fill her pockets with
seeds and, on visits to
friends, stealthily cast them
around their gardens where
the plants would later
appear 'mysteriously'.*

This clump-forming perennial has spiny green foliage marbled with white. From the base leaves, in midsummer to early autumn, spring short, stiff stems that are branched like delicate candelabras; these display the flowerheads of *Eryngium variifolium*, which have a conical shape reminiscent of a small thistle. These are centred on spiny, silvery bracts and the flowers are discreet in colouring: they are greener towards the centre of the flowerhead, becoming bluer-green at the edges.

Care and cultivation

All eryngiums like a sunny postion in well-drained soil; they dislike winter wetness and root disturbance. *Eryngium variifolium* is happy with poor conditions (except for extreme dryness), and may not thrive if the soil is too good.

Uses

Attractive when naturalized in a wildflower patch, and happy in a gravel garden. Give the plant a long drink before using in fresh arrangements. To dry, cut the stems before the flowers are fully open, and hang upside-down in a cool, dry place.

Other recommendations

Eryngium agavifolium: a bold, almost coarse, evergreen perennial with tough, sword-shaped leaves and sharp spines. In late summer it bears blue-green to greenish white flowers and spiny bracts. Prefers moist, well-drained soil in full sun. Height 1–1.5 m (3–5 ft.).

Eryngium eburneum (syn. *E. paniculatum*): a large, clump-forming, evergreen perennial with spiny mid-green leaves. In late summer, tall pale green stems bear groups of tiny spherical flowerheads with whitish green flowers. Height to 1.5 m (5 ft.).

Eryngium giganteum and **E.giganteum 'Miss Willmott's ghost'**: short-lived herbaceous perennials with heart-shaped, mid-green basal leaves. In summer, both display cylindrical flowerheads of initially pale green, then steel-blue flowers. 'Miss Willmott's Ghost' has nearly white bracts. They prefer poor conditions. Height 1 m (3 ft.).

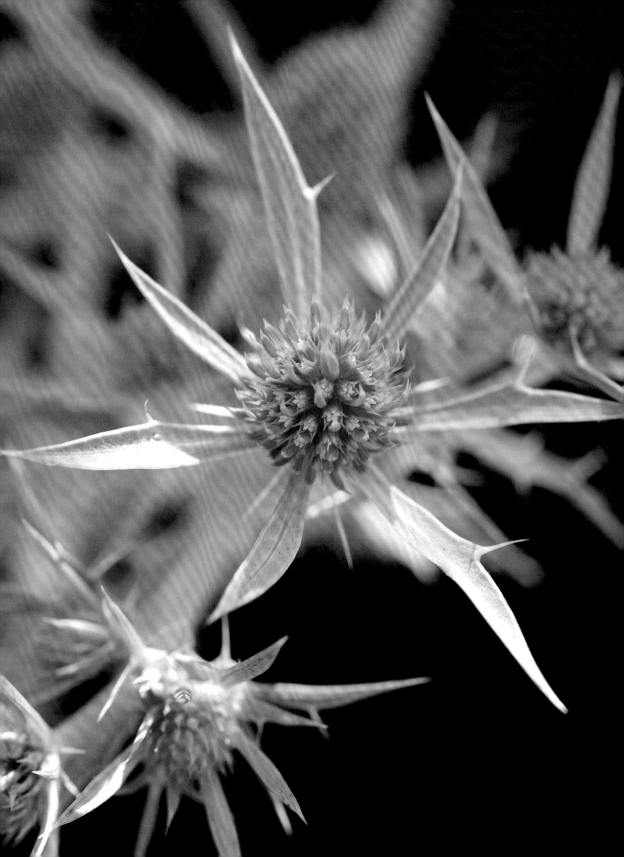

Eucomis autumnalis

pineapple lily

Type of plant
bulbous perennial

Hardiness
USDA Zones 7–10

Position
sun

Height
20–30 cm (8-12 in.)

Spread
20 cm (8 in.)

Surprisingly easy to grow, *Eucomis autumnalis* (syn. *E. undulata*) brings a touch of exoticism to the garden. It looks especially good in a tub or large pot, brought out for summer display. It is of borderline hardiness but often tougher than imagined. Large bulbs produce a rosette of foliage at the base and then a stout stem that bears flower clusters; at the very top grows a tuft of leafy green bracts similar to those of a pineapple—hence its common name of pineapple lily. This plant has faint greenish white flower petals that age to a darker green from late summer to early autumn, making for a long display that fades gradually.

Care and cultivation

Good in a tub or large pot set out for summer display; allow bulbs in the tub to increase from year to year to make generous colonies. As the plant is borderline hardy, put the container in a frost-free shed or cool greenhouse for the winter. In warmer areas, plant bulbs outside, 15 cm (6 in.) deep. Grow in fertile, well-drained soil in full sun, and mulch during severe winters.

Uses

Grow in a sunny, sheltered border or at the base of a warm wall. It makes a striking addition to cut flower arrangements, especially in large compositions.

Other recommendations

Eucomis bicolor: a borderline-hardy perennial, producing pale green flowers margined with purple, borne on maroon-flecked stems in late summer. Height 30–60 cm (12–24 in.).

Eucomis pallidiflora (giant pineapple lily): a robust perennial, bearing greenish white flowers with crinkled margins in late summer. Height 45–75 cm (18–30 in.).

Eucomis pole-evansii: has slender, upright habit and bright green flowers blushed pink in late summer. Has been featured in England's famed Sissinghurst Castle Garden. Height 1.2–1.5 m (4–5 ft.). Quite robust.

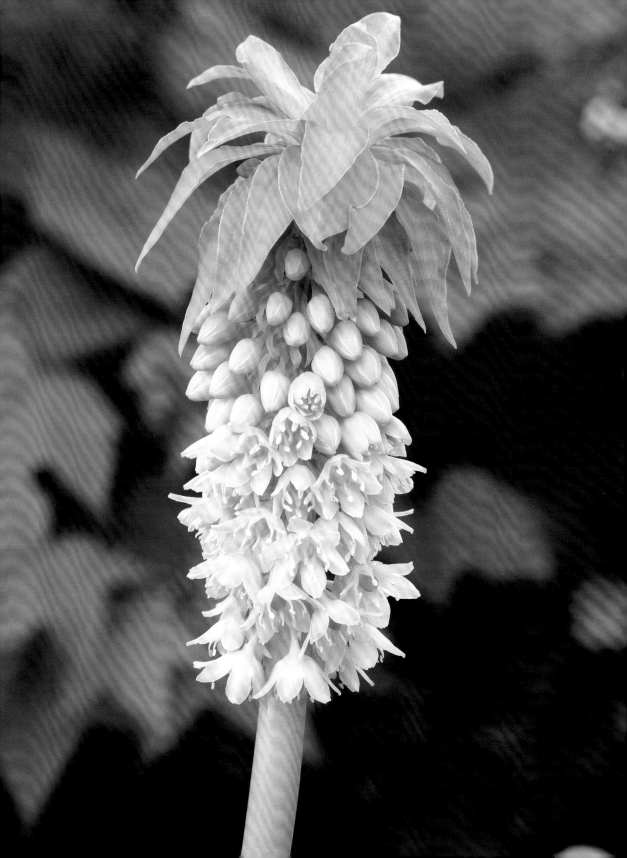

Euonymus fortunei 'Silver Queen'

Type of plant
evergreen shrub or climber

Hardiness
USDA Zones 4–9

Position
sun or partial shade

Height
2.5 m (7.5 ft.), or 6 m (18 ft.)
as a climber

Spread
1.5 m (5 ft.)

The genus *Euonymus* consists of nearly two hundred diverse species, including deciduous, evergreen and semi-evergreen, trees, shrubs and climbers. This euonymus is of the species *fortunei* which is generally comprised of mound-forming non-deciduous shrubs; rather appropriately, its cultivar name is 'Silver Queen' as this evergreen shrub is always regally clothed and has a more upright habit. It is a bushy plant with white-margined dark green leaves; in particular light conditions, the white rimming takes on a minty green cast. The small blooms appear in late spring to early summer, looking a little like a small, bleached version of an ivy flower. These flowers only appear on old plants but, despite their recessive appearance, when they arrive in profusion they are worth the wait. 'Silver Queen' will also climb if given support and looks good lighting up a shady wall.

Care and cultivation

This cultivar is easy to grow and tolerant of a wide range of conditions and soils, even withstanding dry positions. *Euonymus* cultivars are best grown in poor soil and full sun; sunlight will encourage the variegation. (Cut out stems of leaves that may have reverted to plain green.) All climb vigorously with support.

Uses

Use as a specimen shrub, at the rear of a border, or as formal hedging. Train against a shady wall or allow to ramble through a tree. Both foliage and flowering stems are valuable in fresh flower arrangements.

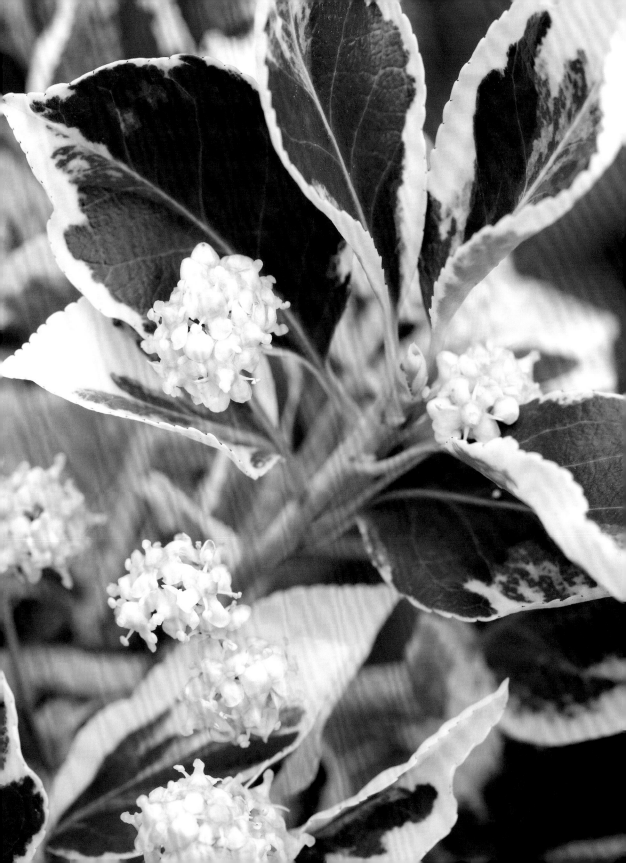

Euphorbia lathyris
mole plant

Type of plant
biennial

Hardiness
USDA Zones 5–9

Position
sun to partial shade

Height
30–120 cm (12–47 in.)

Spread
to 30 cm (12 in.)

Euphorbia is a large and very diverse genus of about two thousand species of annuals, biennials, evergreen, semi-evergreen and herbaceous perennials. *Euphorbia lathyris* is a biennial commonly known as mole plant or caper spurge. It produces striking blue-green leaves that are angled sharply from a central purple-flushed stem. The flower parts, without petals and of minute size, are greenish yellow and cupped inside emerald-green bracts. This blend of diverse greens appears in summer; the mix of blue, purple, yellow and green hues makes this common euphorbia a chic addition to a design scheme.

Care and cultivation

Euphorbia lathyris likes a well-drained, light soil in full sun but will tolerate some shade.

All plants in the genus *Euphorbia* have a white, milky sap that is poisonous and may cause severe skin reactions. Transplant when young, or from containers, before the long tap roots become too established.

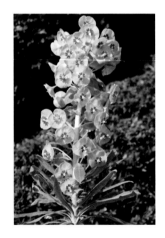

*Euphorbia
characias*

Uses
The coloured bracts and foliage provide long-lasting greenery in the border or in flower arrangements. To prepare for arrangements and prevent the milky sap from leaking out, sear the ends of the stems for twenty seconds in boiling water.

Euphorbia lathyris *is referred to as the mole plant because some gardeners believe that it somehow repels the mischief-making mammal. Although the milky sap that euphorbias excrete causes skin irritation, some believe it to be a cure for warts—but do not try this at home!*

Other recommendations
Euphorbia characias: an upright, evergreen shrub with biennial shoots. It has yellow-green flower–like forms (called cyathia) with 'eyes' of purple-black nectar glands; these are cupped by a ring of green modified leaves and are produced in early spring to early summer. Height 1.2 m (4 ft.).

Euphorbia myrsinites (myrtle euphorbia): an evergreen perennial with trailing stems up to 30 cm (12 in.) long of succuluent, blue-grey leaves. In mid spring it bears cyathia and modified leaves of bright greenish yellow. Height 10 cm (4 in.).

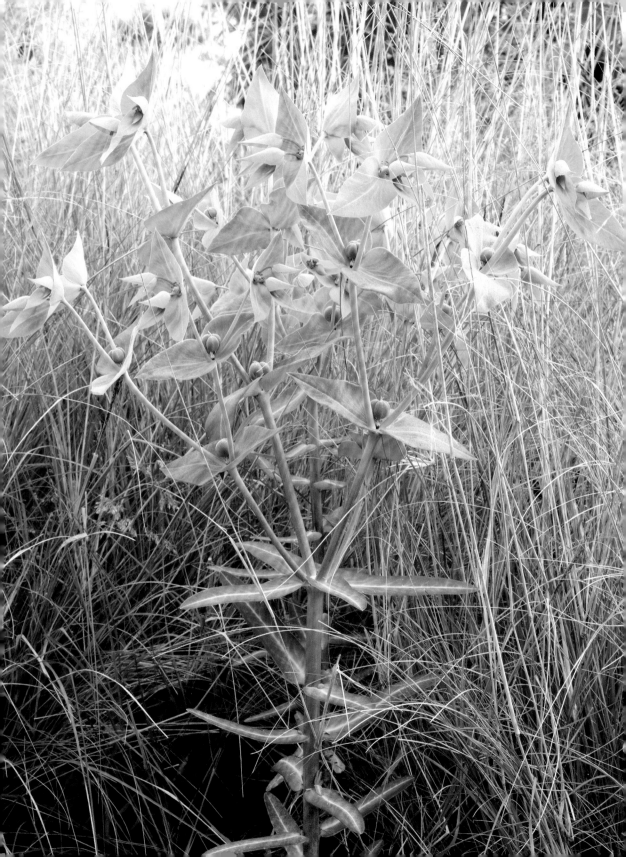

Eustoma grandiflorum 'Piccolo Green'

lisianthus, Texas bluebell

Type of plant
herbaceous annual

Hardiness
USDA Zones 8–10

Position
full sun

Height
60–90 cm (24–35 in.)

Spread
30 cm (12 in.)

Commercial growers of lisianthus often cultivate them in open-sided greenhouses, which helps to produce the coveted long-stemmed, florist-friendly blooms.

If *Eustoma grandiflorum*—better known as lisianthus, or the Texas bluebell—had never been discovered by breeders, this humble plant might still be languishing in its native riverbeds of the southwestern United States. Today, *Eustoma grandiflorum* and its cultivars are such popular cut flowers that commercial growers struggle to meet demand. Despite being grown mainly as annuals for arrangements, these plants can also lend interesting textural variety to a border. In summer, the slender furled buds of 'Piccolo Green' open into a relaxed, bell-like shape. The elegant flowers are borne on long stalks, sometimes in sprays and sometimes singly. The stems and foliage are a soft grey-green and the whitish petals of its blooms overlap, like layers of chiffon, to produce a pastel apple-green.

Care and cultivation

Grow in well-drained, neutral to alkaline soil in full sun where the plant can happily put down its tap root. Give some support to the stems. To avoid frost and produce cut flowers late in the season, grow as container plants in a temperate greenhouse; the optimum conditions are when the minimum temperature is $15°$C ($59°$F) and the maximum $25°$C ($77°$F).

Uses

In warmer areas, use as an annual plant in a border or cutting garden, with support. Grow improved F1 hybrids for cutting. *Eustoma grandiflorum* 'Piccolo Green' makes a long-lasting cut flower with a good-sized bloom measuring about 5 cm (2 in.) across; the subtle grey-green shade and rose-like shape makes it especially desirable in arrangements. To prepare, cut the stem ends, removing at least 2.5 cm (1 in.). Do not allow the flowers to get wet as the petals will become transparent and turn brown.

Fritillaria bithynica

Type of plant
bulbous perennial

Hardiness
USDA Zones 8–10

Position
sun

Height
12 cm (5 in.)

Spread
8 cm (3 in.)

*Fritillaria
acmopetala*

*Fritillaria was named
by Joseph Pitton de
Tournefort, a 17th-century
French botanist who was
first to define the notion
of 'genus' in the context of
plants. The name may well
have been borrowed from
the Latin* fritillus, *meaning
'small dice box', due to
the distinctive spotted
markings and boxy shape of
many fritillaries.*

While some fritillaries are notoriously tricky to grow, the dwarf *Fritillaria bithynica* is a very adaptable plant that thrives in a sunny bed in well-drained soil. It has graceful bell-shaped flowers that drop their heads shyly, displaying their silvered green exteriors; the petals and bracts fuse seamlessly into one another, and are called tepals. A glossy yellow-green begins at the edges of these tepals and continues inside the flowerhead. The leaves are a glaucous green, giving the whole plant a subtle movement of colour from blue shades to fresh greenish yellow. It lights up the garden in mid to late spring.

Care and cultivation

The fragile bulbs need to be handled carefully and planted at four times their own depth. Plant in a sunny position in fertile well-drained soil with added grit. This plant may need winter protection.

Uses

Fritillaria bithynica should be grown in a rock garden, in a raised bed or border. Its small flowers bring a delightful touch of the exotic to wildflower arrangements, and they are reasonably long-lasting in water.

Other recommendations

Fritillaria acmopetala: a bulbous perennial with pendent, bell-shaped pale green flowers and tepals that are folded back and partly reddish brown. Height to 40 cm (16 in.).

Fritillaria sewerzowii (syn. *Korolkowia sewerzowii*): a stout-stemmed, bulbous perennial with grey-green leaves. In spring it produces clusters of nodding greenish yellow to vivid-purple-throated flowers. Quite robust. Height to 30 cm (12 in.).

Fritillaria thunbergii: a bulbous perennial with glossy, mid-green leaves. In spring, bears clusters of bell-shaped creamy white flowers faintly checked or veined green. Robust. Height to 60 cm (24 in.).

Fritillaria verticillata: tall and elegant, with linear foliage. Smallish, pale green bells appear in late winter to mid spring with tendril-like bracts that attach the plant to nearby vegetation. Height 20–60 cm (8–24 in.).

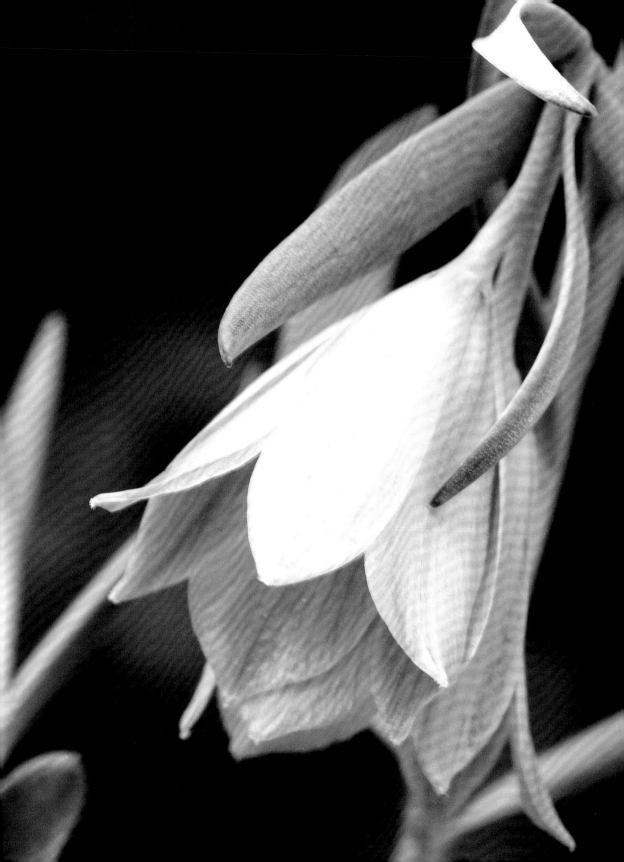

Galanthus nivalis 'Virescens'

green snowdrop

Type of plant
bulbous perennial

Hardiness
USDA Zones 3–7

Position
partial shade

Height
10 cm (4 in.)

Spread
10 cm (4 in.)

When British soldiers returning from the Crimean War brought back bulbs of Galanthus plicatus, *Victorian plant enthusiasts were inspired to hunt for new varieties. Since then, snowdrops have incited great passion in collectors, who are dubbed 'galanthophiles'.*

Snowdrops, the name by which *Galanthus* species and cultivars are best known, emerge in shady corners in late winter to mid spring. Hailed by St. Francis of Assisi as a sign of hope after winter snows, they are the flowers most associated with the beginning of a new year. *Galanthus nivalis* 'Virescens' is perhaps especially cheering due to the freshness of its almost entirely green, single flowers with petals displaying a mere border of the usual white. Snowdrop enthusiasts are probably used to some green markings, especially on the inside segments of a snowdrop flower, but the limey outer petals of this cultivar make it stand out from the crowd.

Care and cultivation

Grow in humus-rich, moist but well-drained soil that does not dry out in summer, in partial shade. In the garden, the best way to propagate is by dividing them 'in the green', just after they have flowered.

Uses

Most snowdrops are vigorous and easy to grow. They may struggle in dense turf, but in thin grass, near trees or in the shade of a hedge, they are likely to flourish. They also grow well in borders and rock gardens but are best left undisturbed. Do not plant them near other plants that need regular division. For flower-arrangers, the honeyed scent of an early bunch of snowdrops brought into the house is irresistible. Avoid contact with the bulbs, though, as they can irritate skin.

Other recommendations

Galanthus '**Merlin**': a vigorous bulbous perennial with narrow grey-green leaves. In late winter and early spring, it produces large dumpy flowers with entirely green inner segments. Height 18 cm (7 in.).
Galanthus plicatus: a bulbous perennial producing broad, dull green leaves with glaucous central bands and recurved margins. In late winter and early spring, it bears flowers with a single green mark at the tip of each inner segment. Height to 20 cm (8 in.).

Galtonia viridiflora

green summer hyacinth

Type of plant
bulbous perennial

Hardiness
USDA Zones 7–10

Position
sun

Height
1.2 m (4 ft.)

Spread
38 cm (15 in.)

Galtonias are native to the moist grasslands of South Africa. Flowering in late summer and early autumn, the fresh pale green blooms of *Galtonia viridiflora* are most welcome. Arching stems, rising from relaxed, lance-shaped leaves, bear an abundance of nodding, trumpet-shaped flowers.

Care and cultivation

In the spring, plant the large bulbs very deeply and leave them undisturbed. Grow in fertile, well-drained soil that is kept moist from spring to summer, in a warm and sunny position. In areas with severe winters, lift and pot up in late autumn and overwinter in a cool greenhouse. If planted outdoors in borders, protect with a deep mulch in winter. Divide plants in early to late spring.

Uses

It works well as a vertical accent to a border, or as a focal point in a patio pot. The waxy flowers are excellent in flower arrangements.

Other recommendations

Galtonia candicans: slightly larger than *G. viridiflora*, its upright stems bear pendent, bell-like flowers coloured greenish white in late summer. They have a light fragrance. Height 1.2 m (4 ft.).

Galtonia princeps: a shorter, stockier plant with green flowers and upright leaves. Height 50 cm (20 in.).

Galtonia
candicans

The British garden writer Beverley Nichols had a penchant for Galtonia candicans. *In* Forty Favourite Flowers *(1964) he wrote: "On an August night, when the moon is full, there is an almost ectoplasmic radiance around its petals".*

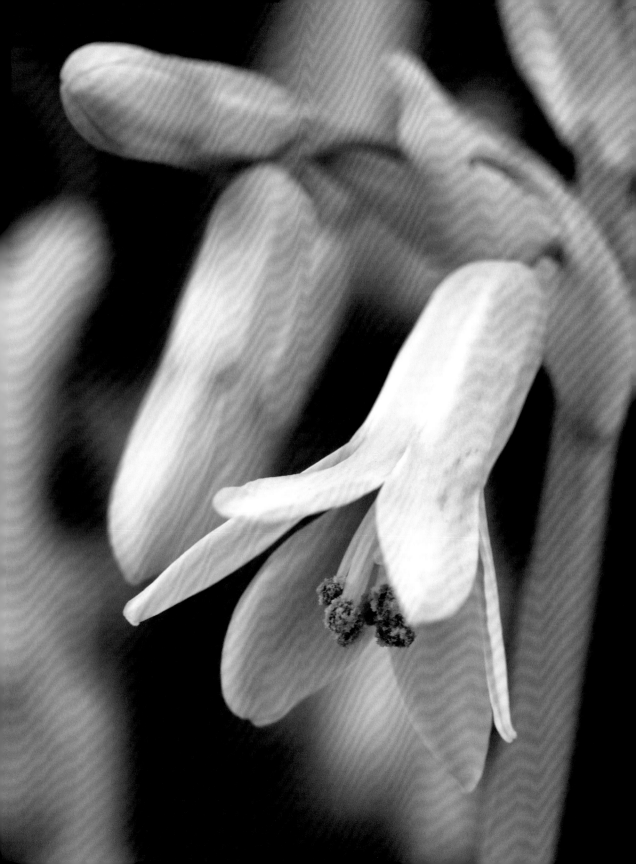

Garrya elliptica

silk tassel bush

Type of plant
evergreen shrub

Hardiness
USDA Zones 8–10

Position
sun or partial shade

Height
up to 4 m (12 ft.)

Spread
up to 4 m (12 ft.)

The genus Garrya *was named after Nicholas Garry (1782–1856), who was right-hand man to the botanist David Douglas (of Douglas fir fame) on his early-nineteenth-century travels in the northwestern United States.*

Although the flowers of *Garrya elliptica* have no petals, they still manage to be striking because they are grouped together in long pendent strings, or catkins. The male and female catkins grow on separate plants and—it must be said—the male versions are generally more attractive than the females, which produce a dull brown fruit after the male catkins have finished their display. The weeping male catkins are grey-green, contrasting with the light-absorbing dark colour of the evergreen leaves. These clustering strings arrive in midwinter to early spring and flutter in the vernal winds, bringing an intriguing sense of movement to the garden. Another common name—quinine bush—is a reference to the plant's bitter-tasting bark, leaves and fruit.

Care and cultivation

Grow in reasonably fertile, well-drained soil in full sun or partial shade. *Garrya elliptica* needs shelter from cold winds in frost-prone areas. Prune immediately after flowering in early spring to allow new growth to form.

Uses

Grow in a shrub border, against a wall or fence, or as a windbreak—especially in coastal areas. The contrast between dark foliage and delicate catkins is of great use in flower arrangements.

Other recommendations

Garrya elliptica '**James Roof**': produces silver-grey catkins 20–30 cm (10–12 in.) long. Flowers late autumn to late winter. Height 4 m (12 ft.).

Gladiolus 'Emerald Spring'

Type of plant
bulbous perennial

Hardiness
USDA Zones 8–10

Position
sun to partial shade

Height
60 cm (24 in.)

Spread
8–10 cm (3–4 in.)

*Gladiolus corms
will produce flowers
approximately one hundred
days after planting.*

Rarely do gardeners have lukewarm feelings for *Gladiolus*: it seems to be either dearly loved or deeply despised. Sadly, it bears a reputation of being rather vulgar, with the usual image of the flower being brashly pink-coloured. Not so the green varieties, many of which are smaller in form and look like exotic foliage. For green gladioli, it seems having less contrasting colour endows the flowers with a more 'sophisticated' look. 'Emerald Spring' is deemed the greenest of those gladioli that have no other colour. It flowers between midsummer and early autumn, depending on when the corm is planted, and produces about twenty ruffled, medium-sized flowers. These open in sequence, blooming and fading from the bottom of the flower spike.

Care and cultivation
Gladioli like well-drained soil, so add grit to the planting area if necessary. The corms of this small cultivar are traditionally 'lifted' each autumn, but milder winters mean you can take a chance on leaving them in situ. Plant at intervals in spring to ensure flowering throughout the summer. Place in clumps for display, or in rows for cutting. Stake each plant, watering and dead-heading regularly.

Uses
A good bedding plant when used as a display in groups in a border. Try a serpentine line of them through other planting (which has the advantage of hiding any staking). Green varieties can also look good planted in among tall grass if the site is open and they are given enough room to thrive.

They are wonderful for flower arrangements, especially in high summer when most luscious, fresh green has faded from foliage plants. Remove the bottom foliage from the flower spike; these sword-shaped leaves can be used alone, or to give structure to an arrangement.

Other recommendations
Gladiolus **'Green Jeans'**: produces small, ruffled green flowers with ivory throats in late summer. Flower spike is 60 cm (24 in.) long, with twenty-four buds (of which seven are open at any one time). Height 1.3 m (4 ft.).

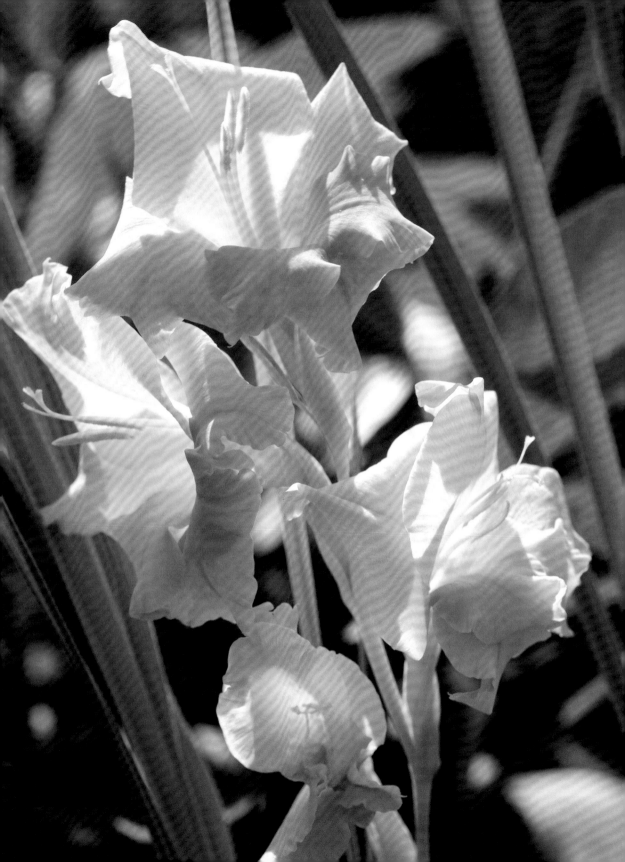

Hacquetia epipactis

Type of plant
rhizomatous perennial

Hardiness
USDA Zones 4–9

Position
partial shade

Height
5–15 cm (2–6 in.)

Spread
15–30 cm (6–12 in.)

This plant forms satisfying clumps of strong emerald green leaves after it has flowered. The tiny yellow flowers are surrounded by lettuce-green bracts that have a robust, glossy quality. It is a little like *Eranthis*, the winter aconite, as it brings an early shot of luminous colour to the winter landscape.

Care and cultivation
Hacquetia epipactis likes humus-rich, moist but well-drained, neutral to acid soil in partial shade. Propagate by division in spring (taking care not to allow the plant's roots to dry out), or by seed in autumn. This plant is not invasive.

Hacquetia epipactis 'Thor'

Uses
It is best placed in a rock or woodland garden, or other moist well-shaded area. Take care that it is not smothered by taller plants. During the duller months of the year, it brings a sense of freshness into the house when used as a cut flower.

Other recommendations
***Hacquetia epipactis* 'Thor'** (syn. *H. epipactis* 'Variegata'): produces a focus of yellow flowers amid its creamy variegated leaves and bracts, mirroring the dappled shade of woodland. Height 5–15 cm (2–6 in.).

Place Hacquetia epipactis *in a shaded pot near the house to brighten an otherwise colour-starved winter garden.*

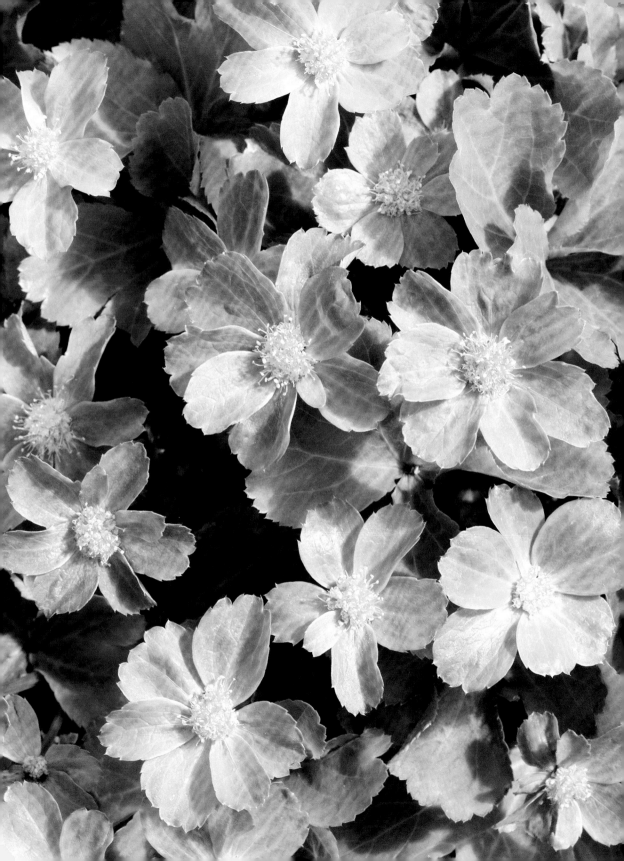

Hedera hibernica 'Deltoidea'

sweetheart ivy

Type of plant
evergreen climber

Hardiness
USDA Zones 7–11

Position
sun or shade

Height
to 5 m (15 ft.)

Spread
variable

The species Hedera hibernica *is often known as Atlantic or Irish ivy. In fact it is rare in cultivation in Ireland and probably not native there at all. The misnomer came from a horticulturist who was 'unreliable in his labelling'.*

Hedera hibernica 'Deltoidea' probably gets its cultivar name from the somewhat triangular shape of its glossy green leaves; in fact, they more closely resemble a heart shape and the plant is often known as sweetheart ivy. It is a strong climber, but also quite slow growing. Like all ivies it has two stages of growth: first comes the juvenile creeping or climbing stage, followed by the production of shoots that grow upwards into aerial 'bushes'. In the autumn these clusters of growth produce yellowish green flowers, arranged in spherical flowerheads. *Hedera hibernica* 'Deltoidea' has a particularly delicate green flower that illuminates the shady conditions in which it thrives. An often overlooked plant, this ivy deserves a second glance.

Care and cultivation

Ivies tolerate a range of conditions, but grow best in fertile, humus-rich, preferably alkaline, moist but well-drained soil. Like other green-leaved ivies, this plant tolerates shade. If grown on a wall, ivies will not damage sound brickwork, but may dislodge loose mortar and damage paintwork. Dense-growing ivy like *Hedera hibernica* 'Deltoidea' makes excellent ground cover, thriving even in dry shade. It can be trimmed at almost any point, but late winter is a good time for tidying up.

Uses

Useful for covering a wall or tree trunk, and excellent for underplanting shrubs or as ground cover over bulbs and other shade-tolerant plants. Also good for espaliers, container plantings and erosion control. Ivies can be trained on wire frames to produce topiary features. The flower stems and heart shaped leaves of 'Deltoidea' are long-lasting, attractive additions to flower arrangements. Avoid contact with the sap, as it can cause skin irritations.

Other recommendations

Hedera canariensis (Canary Island ivy, North African ivy): a vigorous climber with glossy, bright green leaves on red leaf-stalks and green flowers in autumn. Suitable for a sheltered wall. Height 4 m (12 ft.). Not hardy in cold regions.

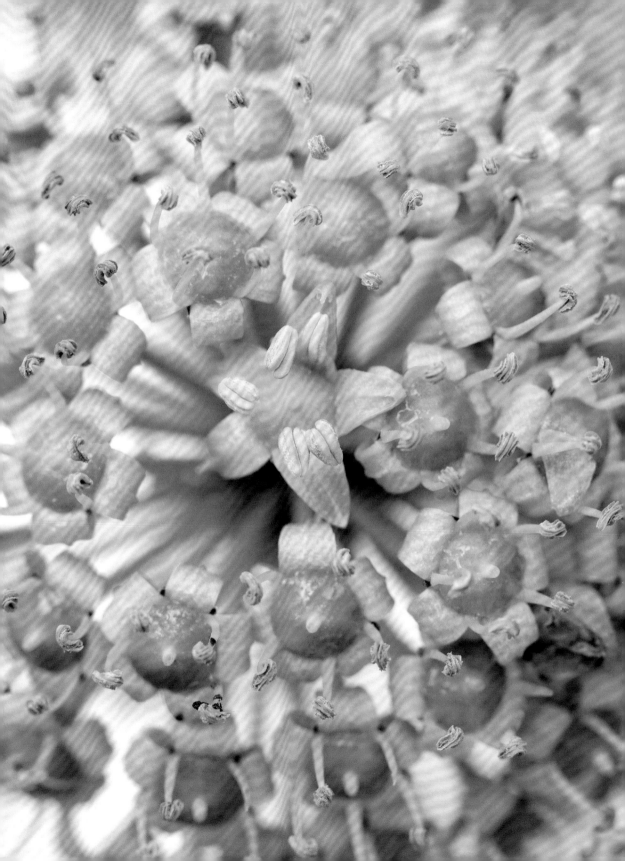

Helleborus torquatus
'Double Green'

Type of plant
herbaceous perennial

Hardiness
USDA Zones 6–9

Position
sun or partial shade

Height
20–40 cm (8–16 in.)

Spread
30 cm (1 ft.)

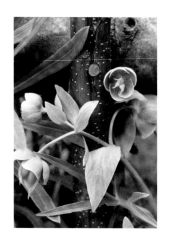

Helleborus
foetidus

Hellebores have been cultivated since the Middle Ages, mainly in monastery gardens. They were used for a variety of medicinal purposes—as a purgative to balance bodily 'humours', in the treatment of nervous disorders, and as a constituent of a wine given to induce abortion.

Some of the best double-flowering *Helleborus* hybrids are produced from the clump-forming species *H. torquatus*, which boasts deciduous mid-green leaves and beautifully shaped flowers that range from violet-purple to green. Purists may feel that it is a case of 'gilding the lily' to double the flowers of an already perfect bloom, but 'Double Green' must dispel these doubts: the lime-green, pendent flowers with their overlapping petals are an early delight. They arrive from midwinter to early spring before the leaves appear. Flowers can be up to 4 cm (1.5 in.) across.

Care and cultivation

This hellebore favours neutral to alkaline soil in full sun or dappled shade. Avoid dry or waterlogged soils, and provide shelter from strong, cold winds. The thick, tough roots resent disturbance; buy young or pot-grown plants and propagate by division in autumn. Herbaceous hellebores respond well when all of their old foliage, whether dead or not, is removed in early winter as it can carry disease. Without old foliage, the flowers are also shown to greatest advantage.

Uses

Hellebores generally look best when grown in masses in a mixed or shrub border, as ground cover, or naturalized in shady locations under trees. Smaller forms such as this one are ideal for the rock garden. Such early-flowering plants deserve to be near a window, patio or entrance. Be careful when handling, as the sap can irritate skin.

Other recommendations

Helleborus foetidus (stinkwort): an upright perennial with biennial stems. The dark green leaves smell unpleasant when crushed. From midwinter to mid spring it bears pale green bracts and pendent, bell-shaped, green flowers that are sometimes pleasantly scented and become rimmed purple with age. Height to 80 cm (32 in.).

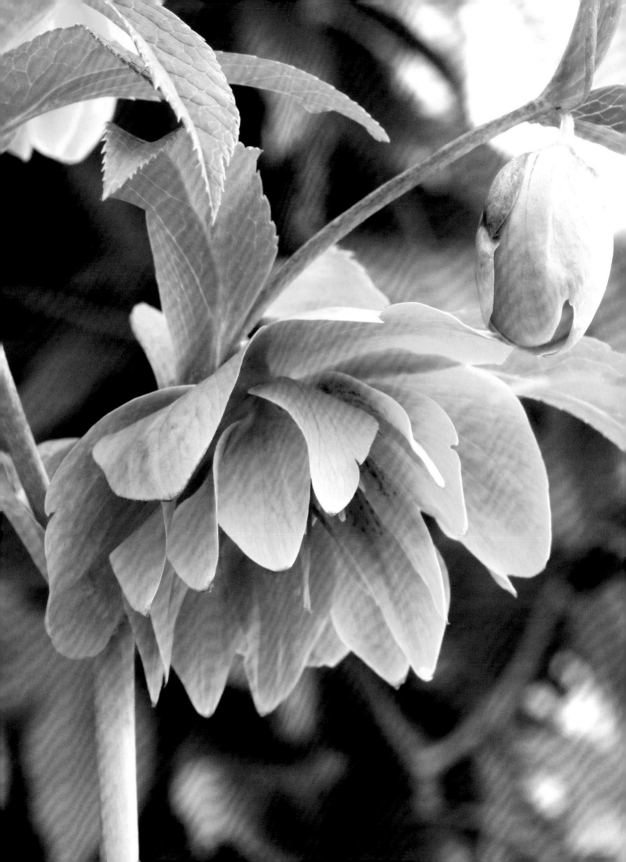

Hemerocallis 'Green Flutter'

daylily

Type of plant
evergreen perennial

Hardiness
USDA Zones 4–10

Position
sun to partial shade

Height
50 cm (20 in.)

Spread
1 m (3 ft.)

Hemerocallis
'Easy Ned'

Most of the cultivars of Hemerocallis *have flowers that last for only one day; some daylilies, such as the yellow* H. citrina *var.* vespertina, *are nocturnal, with flowers that open in late afternoon and last throughout the night.*

'Green Flutter' may be only one of thirty thousand named cultivars of *Hemerocallis* (daylily) but it is worth singling out. It blooms repeatedly throughout summer and—thanks to resourceful plant breeders—for an extended day-length. It is also evergreen, with elegant narrow leaves. The flowers are almost star-shaped and shine out a luminous yellow—but what makes 'Green Flutter' so attractive is that its blooms shade to distinctive green throats. Against this background, the dark anthers of the flower are a prominent feature.

Care and cultivation

Plant 'Green Flutter' and other evergreen *Hemerocallis* species and cultivars in spring rather than autumn, and grow in fertile, moist but well-drained soil; all varieties mentioned on this page prefer full sun. Mulch in late autumn or spring. In spring, until buds develop, water freely and apply a balanced liquid feed such as tomato fertilizer every two to three weeks. Flowering is inhibited by dry conditions and excessive shade. Divide every two to three years.

Uses

Grow daylilies in a mixed or herbaceoeus border. The ones here may be effective planted in drifts in a wild garden. Daylilies also look good in containers.

Other recommendations

Hemerocallis **'Easy Ned'**: has single flowers with a graceful, spidery form reminiscent of Oriental lilies which appear as late as mid autumn. The blooms are very green-yellow with green throats. Height 1 m (3 ft.).
Hemerocallis **'Green Widow'**: has single flowers that are yellow-green with very green throats, appearing early to late summer. Height 66 cm (26 in.).
Hemerocallis **'Lime Frost'**: produces single flowers of a green and white blend with green throats, in late autumn. Height 68 cm (27 in.).
Hemerocallis **'Missouri Beauty'**: a tall plant with single chartreuse flowers appearing early to midsummer. Height 85 cm (33 in.).

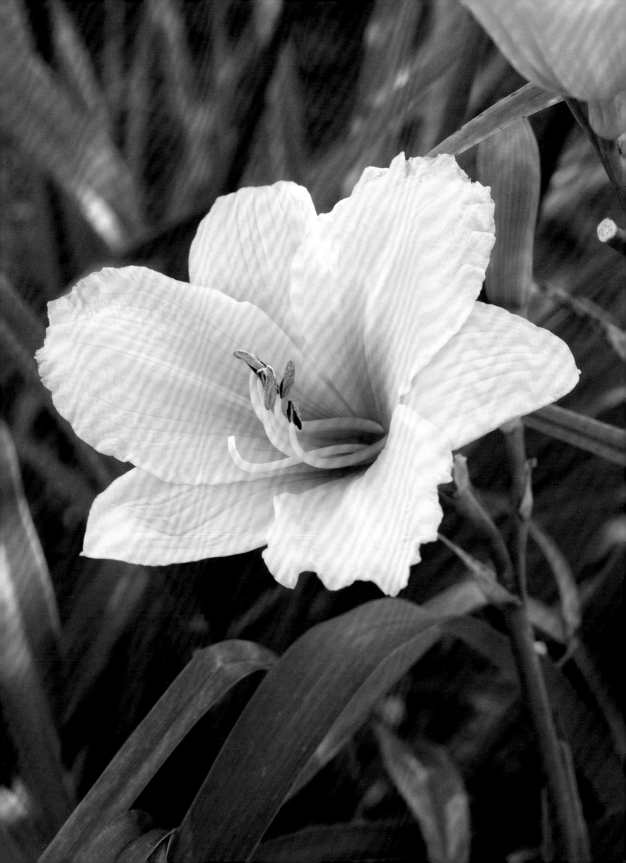

Hermodactylus tuberosus

black widow iris

Type of plant
bulbous perennial

Hardiness
USDA Zones 7–9

Position
sun

Height
20–40 cm (8–16 in.)

Spread
5 cm (2 in.)

Often known as black widow irises, *Hermodactylus* species and cultivars are in the family Iridaceae, although the genus *Hermodactylus* is distinct from *Iris*. The almost-sepia tones of *Hermodactylus tuberosus* give it a sombre air. Found on grassy banks and rocky habitats around mediterranean Europe, it is surely odd, yet somehow attractive—and also deeply fashionable! It has long, linear, square-sectioned, bluish green leaves. The iris-like flowers arrive in spring (or in the drear of midwinter in milder areas) with their beautiful fragrance and weird colouration—a very chic combination of greenish yellow and velvety brown. However, not everyone appreciated the translucent olive hue; the famed herbalist John Gerard called the blossom colour "goose-turd green". Easy to grow, *H. tuberosus* will form large clumps and naturalize well when established.

Care and cultivation

In frost-prone areas grow under protection, such as a bulb frame, to shield the early flowers. Plant the tubers 10 cm (4 in.) deep in autumn, in moderately fertile, well-drained, alkaline soil in full sun. Protect from flooding summer rain; it flowers best in dry summers.

Uses

This unusual plant works well at the base of a warm sunny wall, rock garden or border. It is also good for naturalizing in grass. It is easily forced for winter blooming on a windowsill or in a conservatory, and makes a good cut flower.

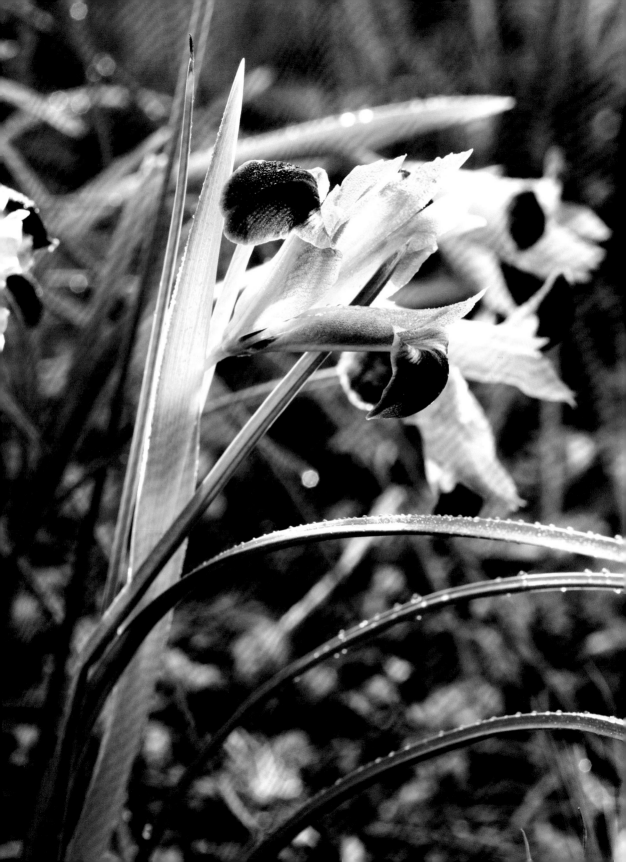

Heuchera cylindrica 'Greenfinch'
coral bells

Type of plant
semi-evergreen perennial

Hardiness
USDA Zones 3–10

Position
sun or partial shade

Height
to 90 cm (35 in.)

Spread
60 cm (24 in.)

The genus Heuchera *is named after eighteenth-century German physician Johann Heinrich von Heucher.*

Native to North America, heucheras are often known by the name of coral bells, making reference to the spikes of pink flowers they often bear. *Heuchera cylindrica* 'Greenfinch' however, produces yellowish green to cream flowers on slender leafless stems. The grass-like spikes light up beautifully in low sun at the end of a summer day. Blooming from mid spring to midsummer, they give good value as flowers and the foliage is also attractive. The flower spikes, measuring up to 60 cm (24 in.) tall, erupt from a rosette of dark green leaves with scalloped edges and paler green mottling.

Care and cultivation
Grow in fertile, but not too rich, moist but well-drained, neutral soil in sun or partial shade; full shade may be tolerated in a moist site but may make the plant lanky. The woody rootstock tends to push upwards like a vegetative tentacle, so mulch annually. Divide and replant in late summer or early autumn, every four to five years, when the crown becomes excessively woody. Plant with the crown just above the soil surface, or replace with new plants.

Uses
This versatile plant works well in informal mixed plantings or more modern schemes. Use as ground cover or in a herbaceous, mixed or shrub border. Because of the lovely foliage it is also useful for under-planting and in pots or baskets. The flowers are attractive to bees. It makes a great cut flower, its flower spikes being particularly valued for their delicate shades of green.

Other recommendations
Heuchera '**Green Ivory**': a clump-forming perennial with strong, erect steams bearing numerous whitish green flowers in early summer. Height 75 cm (30 in.).
Heuchera '**Shamrock**': produces wand-like flowers. The silver-overlaid foliage can reach 20 cm (8 in.) in height, while the flower stalks can grow up to 1 m (3 ft.) tall.

Hippeastrum 'Lemon Lime'

amaryllis

Type of plant
bulbous perennial

Hardiness
USDA Zones 8–10

Position
sun to light shade outdoors, or
bright light indoors

Height
45–60 cm (18–24 in.)

Spread
10 cm (4 in.)

*Hippeastrums originate
from Central and South
America where they
are found in a range of
conditions and climates
from streambanks to stony
hills, at sea level up to
almost alpine regions.*

Known among gardeners as amaryllis, the species and cultivars of *Hippeastrum* come in a range of flower colours spanning white to pink to red, with a few warm corals and oranges sprinkled in here and there. *Hippeastrum* 'Lemon Lime' steps outside this characteristic warm palette, with delicate, trumpeting flowers suffused with fresh citrusy greens. This cultivar is not hardy, but it works well in borders in milder areas and as an indoor specimen. It will cheer up winter months in the house with a display of four to six exotic looking flowers on each erect stem.

Care and cultivation

Plant bulbs in containers in the autumn with neck and shoulders above the soil level, using free-draining compost. They do not like root disturbance, so pot on every three to five years, in autumn. For an early summer display *Hippeastrum* 'Lemon Lime' can be started off in pots in a warm greenhouse or conservatory and then sunk into a border, in its container, after the risk of frost has passed. Hippeastrums will bloom approximately eight to ten weeks after planting.

Uses

Grow in containers, or transfer to borders after frost risk has gone. It makes a good houseplant, and bulbs can be 'forced' for indoor Christmas flowering and decoration. Slightly shorter than many other hippeastrums, *H.* 'Lemon Lime' is an excellent choice for small gardens, little windowsills and tinier interior spaces of any kind.

A dramatic addition to large flower arrangements, it is best cut while the plants are still in bud. The flowerheads bruise easily and lose colour in damaged areas. They can last for three weeks, but the stems may give way before the flowerhead dies. To reinforce it, insert a cane in the hollow stem, plug with cotton wool and secure with an elastic band.

Other recommendations

Hippeastrum **'Emerald'**: displays flower with white petals flecked soft green and light red, with deep green throats. Height 45–60 cm (17–23 in.).
Hippeastrum **'Limona'**: produces pale white-green blooms from winter to midsummer depending on planting. Height 50–65 cm (20–25 in.).

Humulus lupulus 'Aureus'
golden hop

Type of plant
climbing herbaceous perennial

Hardiness
USDA Zones 4–8

Position
sun or partial shade

Height
up to 6 m (20 ft.)

Spread
1.8 m (6 ft.)

Humulus
lupulus
'Aureus' female
flowers

Although the cultivars of *Humulus lupulus* are generally grown for their bright foliage, the delicate greenish white flowers of *H. lupulus* 'Aureus' should not be overlooked. Small male and female flowers are borne on separate plants in mid and late summer. The male flower-heads (right) hang on many-branched stems and each bud is like a tiny greenish pearl. The female flowers (below) may not be so showy, but they have a delicious fragrance and after green buds they open into spidery pink-flushed blooms.

Care and cultivation
Grow in moist yet well-drained, moderately fertile, humus-rich soil in sun or partial shade. However, for best leaf colour this plant should be grown in a sunny position. For best results, cut back every spring to ensure new growth.

Uses
Train over a fence or trellis, or into a large shrub or small tree. The dried inflorescences are useful for flower arrangements.

Other recommendations
***Humulus japonicus* 'Variegatus'**: a perennial with twining, dark green leaves, heavily mottled and streaked with white. It has spikes of green female flowers in mid and late summer and is usually treated as a half-hardy annual. Height 3 m (10 ft.).

The female inflorescences of Humulus lupulus *are used in the brewing of beer to give it aroma and flavour. Fresh, or 'green', hops are good for imparting the fullest 'nose' to the brew, but as they contain over eighty per cent moisture a large amount is needed to give the beer its bitter taste.*

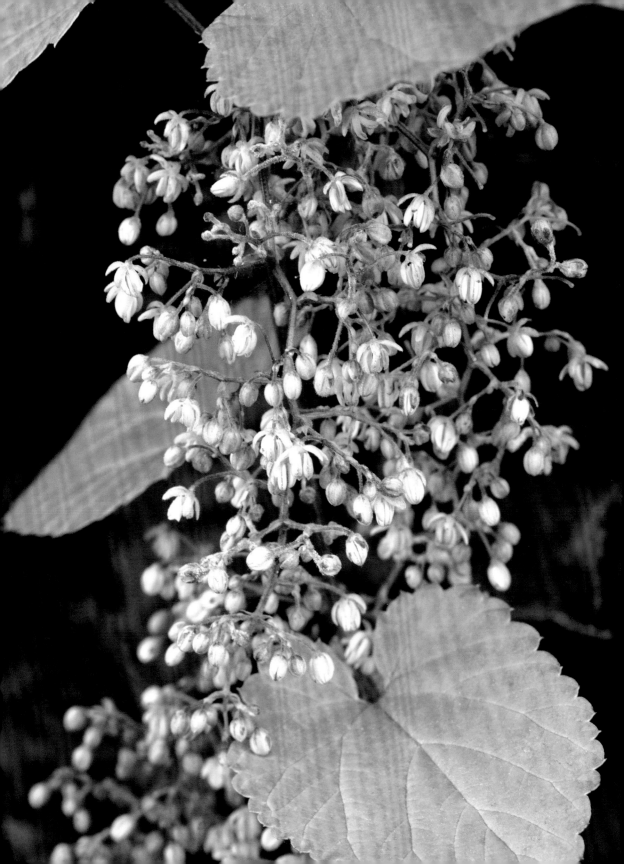

Hydrangea paniculata 'Limelight'

Type of plant
shrub

Hardiness
USDA Zones 3–8

Position
sun or partial shade

Height
2 m (6 ft.)

Spread
2.5 m (8 ft.)

The name **Hydrangea**
is derived from a Greek
description of the shape of
the seedheads, which were
thought to resemble Greek
water vessels.

Hydrangea paniculata 'Limelight' is a vigorous shrub with an upright habit. The luxuriant conical flowers have a new-green tinge to their creaminess, which makes the blooms all the more welcome and refreshing when they arrive in late summer and early autumn. The blooms gradually age to a soft lavender-pink.

Care and cultivation
Grow in moist but well-drained, reasonably fertile, humus-rich soil in sun or partial shade. Provide shelter from cold or drying winds. Unlike pink or blue hydrangeas, the colour of *H. paniculata* 'Limelight' is not affected by soil acidity. To obtain larger flowerheads, cut back the previous season's shoots to within a few buds of the woody frame.

Uses
Works well in a range of sites—as a specimen plant or in a border, by a shady wall or fence or in containers. It yields excellent cut flowers, whether fresh or dried. To dry, hang upside-down in cool dry place.

Hydrangeas can also be preserved using the glycerine method: strip excess leaves from the flowerhead and crush the end of the stem if woody. Mix one part glycerine with two parts very hot water and add an antibacterial agent such as chlorohexidine. Fill a tall container with 5 cm (2 in.) of solution and rest stems in it. Place in a cool, dark place and do not let the solution dry out. Leave for up to ten weeks, until there is a darkening of colour and before beads of glycerine appear on the leaves or petals/sepals.

Other recommendations
Hydrangea arborescens 'Annabelle': produces round-headed masses of white flowers, with green veining on the four petal-like bracts, in midsummer to autumn. As autumn progresses, flowers fade to deeper green. Good winter seedheads. Height 2.5 m (8 ft.).
Hydrangea petiolaris: a climbing hydrangea for a shady spot. In late spring it has lacecap-style flowers that are greenish in the centre before it displays white, flat blooms. Height 15 m (45 ft.).

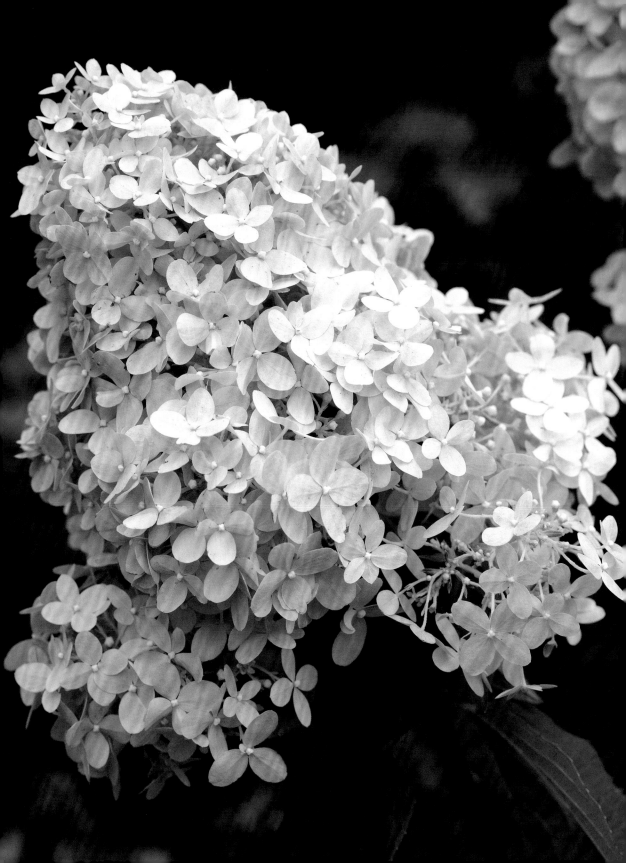

Iris 'Green Spot'

bearded dwarf iris

Type of plant
rhizomatous perennial

Hardiness
USDA Zones 3-10

Position
sun

Height
25–30 cm (10–12 in.)

Spread
20–30 cm (8–12 in.)

According to ancient mythology, Iris was a Greek goddess who ferried messages from the gods of Mt. Olympus to the mortals. Her name in Greek means 'rainbow'.

Irises always bring a touch of the unexpected to the awakening garden, and this variety of bearded dwarf iris is a little charmer. The flowers emerge from mid-green sword-shaped foliage and are mainly white in colour; however, the downward-cascading petals—known as falls—are spotted and veined with yellow-green. This unique-looking iris introduces an enticing freshness to the border in early spring and summer and has the added value of a light fragrance.

Care and cultivation

Bearded irises prefer full sun and neutral to alkaline soil; to grow them in acidic or peaty soils, top-dress with lime before planting for best results. Plant so that the upper part of the rhizome is on the surface of the soil and add a low-nitrogen fertilizer to the shallow planting hole. After planting, remove the top third of the leaves to protect against wind-rock. In exposed areas, for further protection against wind, support with canes in early spring. Divide and replant approximately every three years as otherwise the clumps will become woody and produce fewer flowers. Divide immediately after flowering or in late summer and early autumn. Replant the youngest, healthiest rhizomes from the outside of the clump and destroy the rest.

Uses

This dwarf iris is good at the front of a sunny border or in pots. Give blooms a long drink after cutting as they dehydrate quickly and keep in a cool location away from draughts. As a cut flower it has a short vase life of about three to six days. Poisonous if ingested.

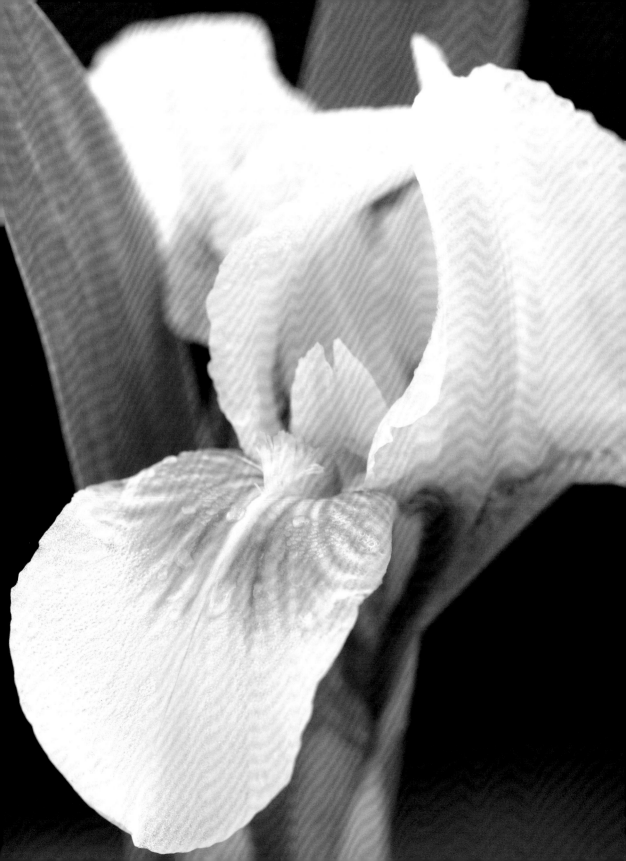

Itea ilicifolia

holly-leaved sweet spire

Type of plant
evergreen shrub

Hardiness
USDA Zones 5–9

Position
sun

Height
3–5 m (10–15 ft.)

Spread
3 m (10 ft.)

Beginning as an upright shrub, *Itea ilicifolia* will gradually spread into a generously sized plant if given the right sheltered position. It always has a dark green appearance because of the glossy evergreen foliage. The toothed leaves are somewhat holly-like—hence its common name. In late summer to early autumn it produces greenish white flowers borne in catkin-like clusters up to 30 cm (12 in.) long. Apart from making an interesting contrast in shape and tone with the dark background foliage, they also have a fragrance redolent of honey. This is most evident in the evening when night-flying insects are attracted to the scent.

Care and cultivation

This evergreen species likes fertile, moist but well-drained soil. Needing protection from cold, drying winds, a sunny south- or southwest-facing wall will suit it best. Mulch young plants in winter. This plant only needs to be trimmed, but it responds well to shaping and this is best done in late winter. It can also be easily wall-trained.

Uses

Use in hedging or a shrub border, or as a specimen shrub. It can be trained against a wall or fence and makes a good backdrop for herbaceous planting. This plant is attractive to butterflies and moths. It provides good long-lasting foliage for flower arrangements, with the added interest of the catkin-like blooms.

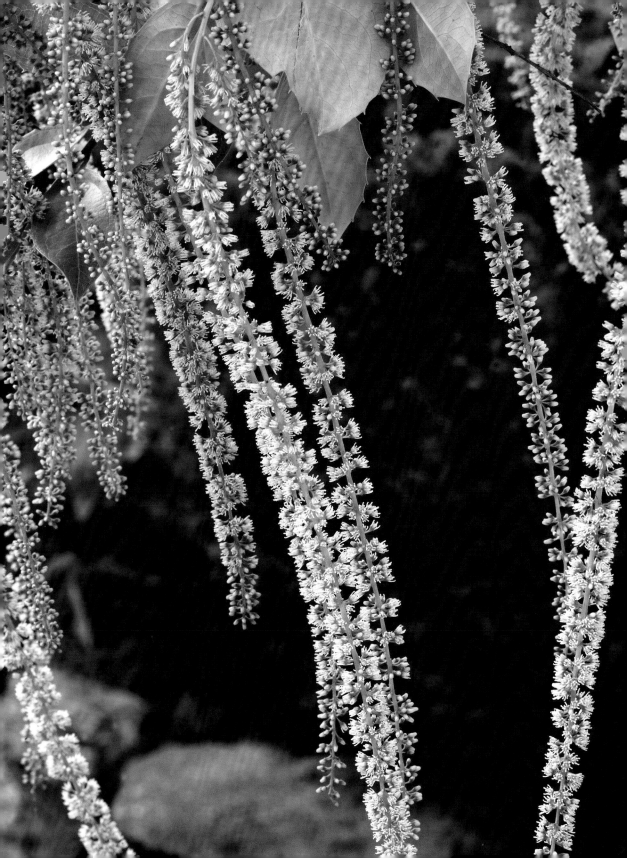

Jovibarba heuffelii 'Bloodstone'

Type of plant
evergreen perennial

Hardiness
USDA Zones 4–11

Position
sun

Height
to 20 cm (8 in.)

Spread
to 30 cm (12 in.)

Plants have been used on roofs for thousands of years, from turf roofs in Ireland to the hanging gardens of Babylon. In the last fifty years this practice has evolved into producing so-called green roofs, living roofs or eco-roofs, which now benefit from well-researched and sustainable design methods.

Forming mat–like areas of intense green, these fleshy plants are becoming very fashionable as they are increasingly being used in eco-friendly architectural green roofs. As *Jovibarba heuffelii* 'Bloodstone' is mainly grown for its foliage, its flowers are all too often overlooked. These succulent-looking flowers rise up on leafy stalks in summer. They are light green in colour and have tiny speckles of fuchsia pink that accentuate the greenness. This small-scale plant is easily cultivated.

Care and cultivation
Grow in poor, gritty, well-drained soil in full sun. Remove old rosettes after flowering. In an alpine house, grow in equal parts loam-based potting compost and grit.

Uses
Good in a rock garden, trough or alpine house. It is also very attractive tucked into the crevices of a wall.

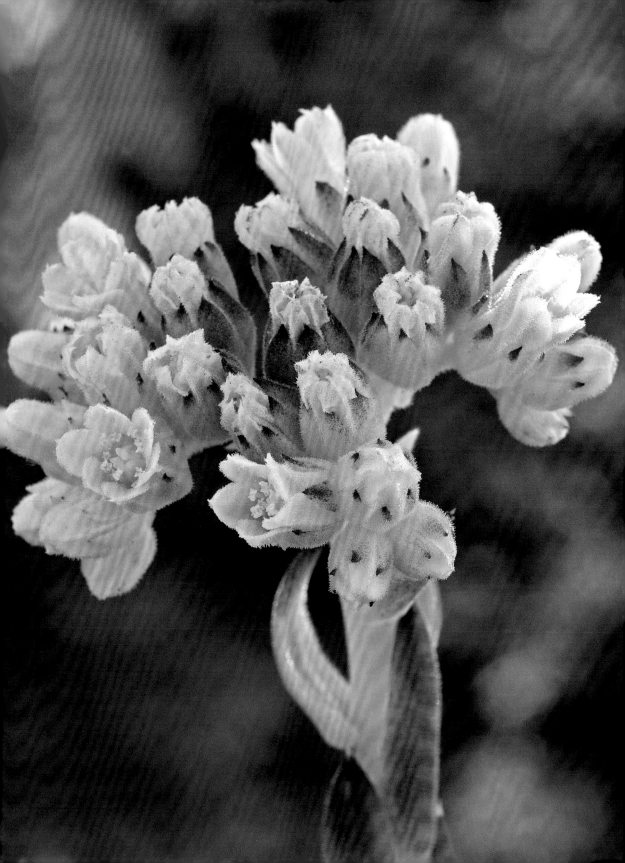

Juncus effusus f. *spiralis*

corkscrew rush

Type of plant
evergreen perennial

Hardiness
USDA Zones 4–9

Position
sun or partial shade

Height
30–60 cm (12–24 in.)

Spread
60 cm (24 in)

A rhyme often taught
to novice horticultural
students, to help with
identification of rushes,
sedges or grasses goes thus;
 Sedges have edges,
 Rushes are round,
 Grasses have joints
 If the cops aren't around.

Juncus is a genus of rushes. Although sometimes mistaken for sedges, which have sharp-edged shoots and grass with jointed stalks, rushes can be identified by the roundness of their stems. *Juncus effusus* f. *spiralis* is particularly eye-catching, and even amusing, in character. Densely growing and leafless, its dark green stems twist and turn in an almost artificial-looking manner. The tangled mass that is often created may have inspired its other common name of curly-wurly. Tiny green flowers emerge in loose clusters along the stems in summer.

Care and cultivation

Corkscrew rushes prefer damp, boggy, acid soil but will adapt to pot culture or garden sites that do not dry out.

Uses

Juncus effusus f. *spiralis* makes excellent decorative ground cover. It is good on moist ground, at the edges of ponds. This plant also makes an interesting addition to a flower arrangement, although it has a fairly short vase life.

Other recommendations

Juncus filiformis **'Spiralis'** (thread rush): produces green flowers late spring to early autumn. Height 20 cm (8 in.).
Juncus tenuis: another green-flowering rush, known as wire grass because of its extremely tough stems. Very useful as ground cover, especially where erosion control is needed. The spiky green flowers arrive from summer to early autumn. Height 15–60 cm (6–24 in.).

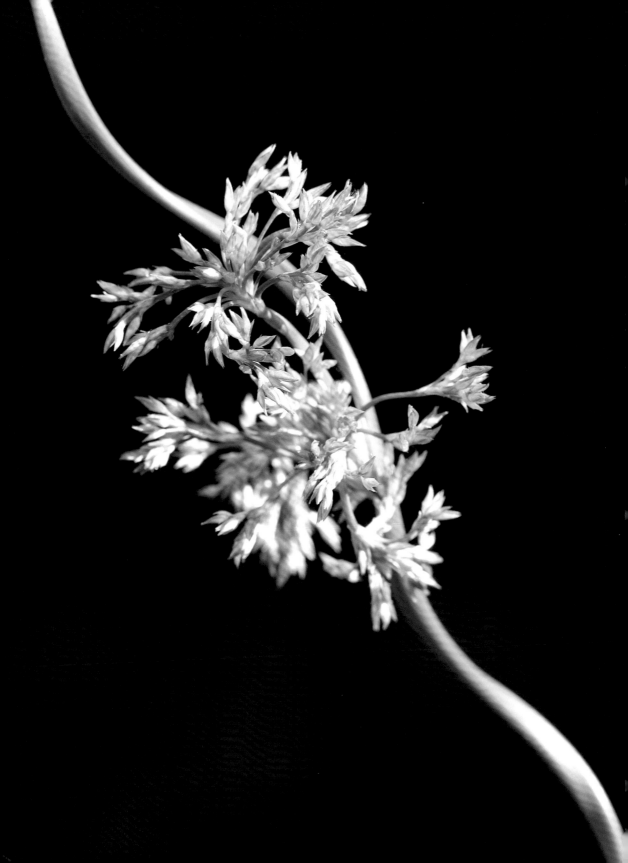

Kniphofia 'Green Jade'

Type of plant
evergreen perennial

Hardiness
USDA Zones 7–10

Position
partial shade to full sun

Height
to 1.2 m (4 ft.)

Spread
60–75 cm (24–30 in.)

Kniphofia 'Green Jade' was raised by British plantswoman Beth Chatto from seed collected in the garden of artist and plant-collector Sir Cedric Morris—who happened to live near her in Suffolk.

The name 'red-hot poker', often bestowed on fiery kniphofias, does not apply to this cultivar. Its green flowers change from cream and then to white in a blend down the length of the flower, the variation in hues giving a sense of moving light upon the conical flower spikes. The slender spikes are on long stalks well above the architectural strap-like leaves and are displayed in late summer to early autumn. There is a variety of colouration in *Kniphofia* 'Green Jade' and the greenest pokers fade to a pale lime green. Despite its delicate looks, it is easy to grow.

Care and cultivation
As kniphofias do not like winter wet, grow in deep, fertile, humus-rich, moist but well-drained, preferably sandy soil, in full sun or partial shade; mulch young plants with straw or leaves for the first winter. It self-seeds, but does not always produce uniformly coloured offspring this way.

Uses
Good in a herbaceous border, it rarely need dividing or replanting. It can also look good naturalized among grasses. Great for the cutting garden; if the bottom flowers are dying, pull these off before arranging. Bees are attracted to *Kniphofia* 'Green Jade'.

Other recommendations
Kniphofia **'Brimstone'**: a distinctive and tough plant with slender green and pale yellow pokers. Flowers late summer to winter. Height 75 cm (30 in.).
Kniphofia **'Ice Queen'**: a robust, deciduous perennial bearing green-budded flowers opening pale primrose yellow, fading to cream in early and mid autumn. Height to 1.5 m (5 ft.).
Kniphofia **'Percy's Pride'**: a deciduous perennial with green-tinted canary yellow flowers borne in late summer and early autumn. Height 1.2 m (4 ft.).

Lavandula viridis

green lavender

Type of plant
evergreen shrub

Hardiness
USDA Zones 8–11

Position
sun

Height
60 cm (24 in.)

Spread
75 cm (30 in.)

The first written reference to lavenders has been traced to the Greek physician Dioscorides in about AD 65. Then, in the Middle Ages, Abbess Hildegard of Bingen (1098–1179) again referred to lavender's medicinal properties. The essential oil of another species, Lavandula officinalis, *is the most widely use therapeutically. It is thought to have a balancing effect on the psyche, and is used to help calm emotion and remove indecisiveness.*

The flower spikes of *Lavandula viridis* are more like those of *L. stoechas* (French lavender) than the traditional kind of lavender found in English cottage-style gardens. The flower spike has a tuft of sterile bracts at its tip, like the waving cockade of French lavender, but the flowers themselves are as pale green as grass under snow. The scent is somewhat different too, having a whiff of citrus about it. The plant is upright and bushy, but is not deemed reliably hardy.

Care and cultivation

Like all lavenders, *Lavandula viridis* prefers well-drained soil and sun. Trim back after flowering but do not cut into old wood unless it is showing signs of producing new shoots. If you do risk planting *L. viridis* in a border, be prepared for its demise by rooting a few cuttings for replacements each year. Take some of the unflowered shoots off the current season's wood and root them in small pots of sandy compost on a greenhouse bench.

Uses

Best grown in containers that can be removed to cover in the winter. The fragrant flower spikes are excellent for fresh flower arrangements and can also be dried; pick mid-morning and hang upside-down in a cool, dry place.

Other recommendations

Lavandula viridis **'Silver Ghost'**: found in New Zealand, this cultivar has silver and white markings on the leaf. It is one of the more tender lavenders but it will overwinter in a frost-free and well-lit greenhouse, conservatory or porch.

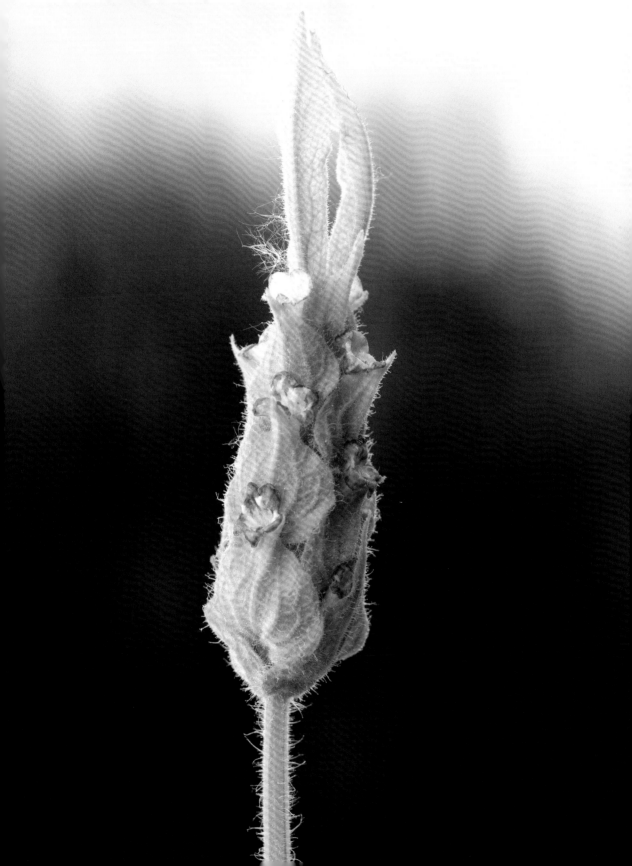

Mitella breweri

Type of plant
rhizomatous perennial

Hardiness
USDA Zones 7–9

Position
partial shade

Height
15 cm (5 in.)

Spread
20 cm (8 in.)

This wild plant can be found in North American woodland. In late spring and summer, the elegant flower stalks of *Mitella breweri* rise from a base of heart-shaped leaves. The tiny, white-green and bell-shaped flowers have petals fringed like hair combs.

Care and cultivation
Grow in moist but well-drained, leafy, acid soil in partial shade. Cut back flower spikes if self-seeding is not wanted. Sow seed in pots in a cold frame in autumn; divide in spring.

Uses
Mitella breweri makes great ground cover in a woodland garden. The tiny stems are also pretty in small flower arrangements, as the developing black seeds in the flowers create a striking and stylish effect.

Other recommendations
Mitella formosana: a perennial with creeping rhizomes and palmate leaves on long slender stems, bearing greenish white pink-tinged flowers in summer. Grow in full to partial shade and moist soil. Height 15 cm (6 in.).
Mitella ovalis (oval-leaved mitrewort): has heart-shaped leaves and green, linear petals. Height 15–30 cm (6–12 in.).
Mitella yoshinagae: a carpeter for woodland, with glossy scalloped rounded green foliage, and pale green fringed flowers in spring. Height up to 30 cm (12 in.).

Moluccella laevis

bells of Ireland

Type of plant
herbaceous annual or
short-lived perennial

Hardiness
USDA Zones 7–10

Position
sun

Height
60–90 cm (24–35 in.)

Spread
23 cm (9 in.)

Despite its common name, this plant in the mint family is not from Ireland, but is native to Turkey, Syria and the Caucasus. The association with Ireland probably comes from its wild green colour. The famous botanist Linnaeus, who named the plant, was rather confused about its origins; wrongly thinking it had been found in the Molucca Islands in Indonesia, he named the genus accordingly.

Cultivated since 1570, *Moluccella laevis* looks wonderfully prehistoric. Its flowers, a symbol of good luck, are surrounded by cup-shaped leaves that grow out of the four-sided stems like the loudspeakers of a public announcement system. They certainly announce themselves with their luscious lime colour and the tiny and fragrant white flowers nestling in their hearts. Later in the season, these cupped leaves become white-veined and papery, making them appealing for dried flower arrangements. This plant is generally treated as an annual, but well-established specimens will return another year by overwintering or through self-seeding.

Care and cultivation

Grow in moderately fertile, moist but well-drained soil in full sun and water regularly. Support growth with twiggy sticks.

Uses

Good for a mixed or annual border or a cutting garden. It is a highly desirable, long-lasting staple for flower arrangements, so grow in as large quantities as possible. When cutting, remove lower leaves and side branches, being careful not to break the plant at these brittle junctions. Give it a long drink before arranging.

The unusual flower spikes are also useful for dried arrangements: hang them upside-down in a cool, dry place. They can also be preserved by the glycerine method—see *Hydrangea paniculata* 'Limelight'.

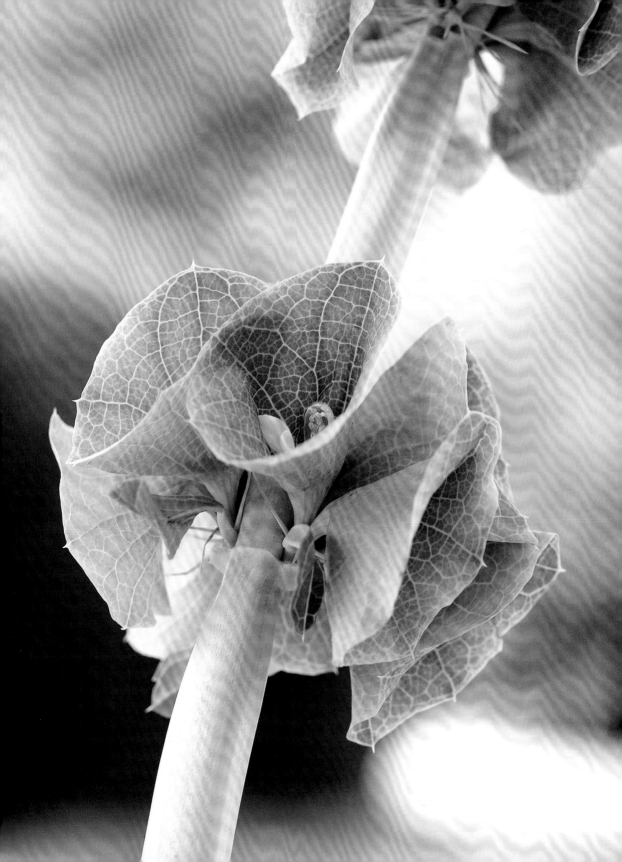

Morus nigra

black mulberry

Type of plant
deciduous tree

Hardiness
USDA Zones 5–11

Position
sun

Height
12 m (36 ft.)

Spread
15 m (45 ft.)

While Europeans tend to grow *Morus nigra* primarily for its edible fruit, it is often grown in North America for the purpose of attracting birds. Before the emergence of dark purple-red and luscious fruit must come the bloom; in late spring and early summer, tiny, cup-shaped, pale green male and female flowers are borne in separate catkins on the same plant. Thereafter, each female flower cluster develops into a single, bright green elongated sphere. In late summer this transforms into an edible, raspberry-like fruit.

Care and cultivation
Grow in moderately fertile, moist but well-drained soil in full sun and shelter from cold, drying winds. Prune in late autumn or early winter, as trees 'bleed' milky sap at other times.

Uses
Grow as a specimen tree.

Other recommendations
Morus rubra (red mulberry): a rounded tree with dark green leaves, turning yellow in autumn. The cylindrical, sweet-tasting green fruit ripens to dark purple in late summer. Height 12 m (36 ft.).

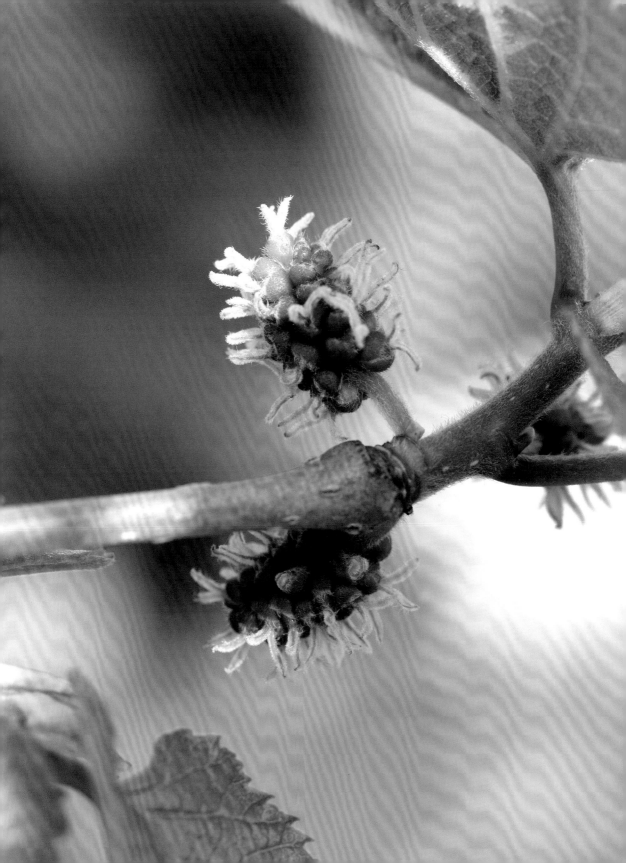

Nicotiana 'Lime Green'

green flowering tobacco

Type of plant
annual

Hardiness
USDA Zones 10–11

Position
sun or partial shade

Height
60 cm (24 in.)

Spread
25 cm (10 in.)

The delight of this green-flowered cultivar of *Nicotiana*, or flowering tobacco, is the fresh lime-green colour of its flowers coupled with a heavy fragrance that is particularly noticeable on warm evenings. It flowers for most of the summer and sometimes into the autumn. Nicotianas usually show their blooms to best effect in the evening, as they close them partially in bright sunlight—so the zingy 'Lime Green' may be best planted in light shade to give sparkle to an area. The flowers are like miniature trumpets, widening out at their mouth from a long thin tube, and are almost 12 cm (5 in.) in length. They are borne on long, slender stems that shoot up from a base rosette of leaves. 'Lime Green' has distinctive concave leaves that are almost spoon-shaped.

Nicotiana langsdorfii

Care and cultivation

Flowering tobaccos are hardy only in frost-free climates and are treated as annuals elsewhere. Grow in fertile, moist but well-drained soil in full sun or partial shade. Plants in windy or open sites need support. All *Nicotiana* species and cultivars have sticky secretions and contact with the foliage may irritate skin.

Uses

On the edge of a woodland garden or in a partially shaded border. It works well with both modern and informal mixed plantings. Cultivars derived from *Nicotiana alata* and *N.* ×*sanderae* are ideal summer bedding annuals, their upward- or horizontally-facing blooms remaining open in full sun.

Nicotiana (tobacco) was vastly important to the first American settlers. John Rolfe, the English colonist who arrived in Jamestown, Virginia in 1607, is thought to have imported Nicotiana tabacum *from the West Indies. Tobacco soon became the colony's major crop for export.*

Other recommendations

Nicotiana langsdorfii: an elegant plant, with flowers hanging gracefully from slender stems. Tubular flowers open out into five petals and are apple-green. Height to 1.5 m (4.5 ft.).

Nicotiana ×*sanderae* **Merlin Series**: a lime-green annual dwarf form, bred for containers. Height 23–30 cm (9–12 in.).

Nicotiana ×*sanderae* **Starship Series**: a lime-green annual cultivar with good all-weather tolerance. Height 30 cm (12 in.).

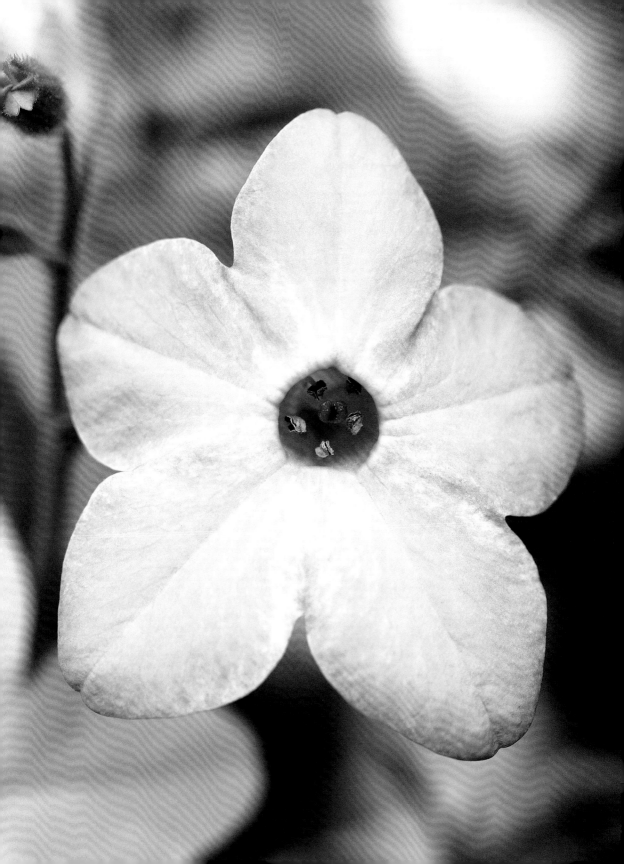

Ornithogalum nutans

drooping Star of Bethlehem

Type of plant
bulbous perennial

Hardiness
USDA Zones 6–10

Position
sun

Height
20–60 cm (8–24 in.)

Spread
5 cm (2 in.)

Bulbs are generally very attractive to mice and other rodents, but luckily Ornithogalum nutans *is not one that they like to feast upon.*

Known commonly as the drooping Star of Bethlehem, this plant is far from common in its looks. It has very pretty soft, silvered flowers which open up into a star shape; each tapering petal is margined white with a grey-green centre. Its structure is like a bluebell, with nodding flowers ranged up a stalk about 23.5 cm (9 in.) tall, and it lasts well when picked. *Ornithogalum nutans* is generally robust and excellent for naturalizing in drier, lighter soils or in short grass. The foliage can turn yellow in late spring, just when the plant is coming into flower.

Care and cultivation
Plant bulbs 10 cm (4 in.) deep. Outdoors, plant fully hardy and frost-hardy species in autumn, in reasonably fertile, well-drained soil, in a sunny situation. *Ornithogalum nutans* and *O. umbellatum* may become invasive. Take care when handling, as the sap may irritate skin.

Uses
This plant is too delicate to make a splash in long grass but works nicely in short turf, at the bottom of a hedge or around the base of a tree trunk as long as the shade is not dense. It is long-lasting and lovely in small arrangements with wildflowers; strip off yellowing foliage.

Other recommendations
Ornithogalum balansae: a slender, bulbous perennial with almost prostrate, mid-green leaves. In early spring it bears flowers, 3 cm (1 in.) across, that are glossy white inside and bright green outside. Height to 8 cm (3 in.).

Ornithogalum montanum: a bulbous perennial with shiny, pale to greyish green leaves. In spring, bears clusters of up to twenty star-shaped white flowers, striped green on the outsides. Height 10–25 cm (4–10 in.).

Ornithogalum umbellatum (Star of Bethlehem): a bulbous perennial with white-veined, mid-green leaves, each with a central silver stripe above; the leaves wither as the flowers open in early summer. Produces clusters of up to twenty long-stalked, star-shaped white flowers, striped green outside. Increases rapidly. Height 10–30 cm (4–12 in.).

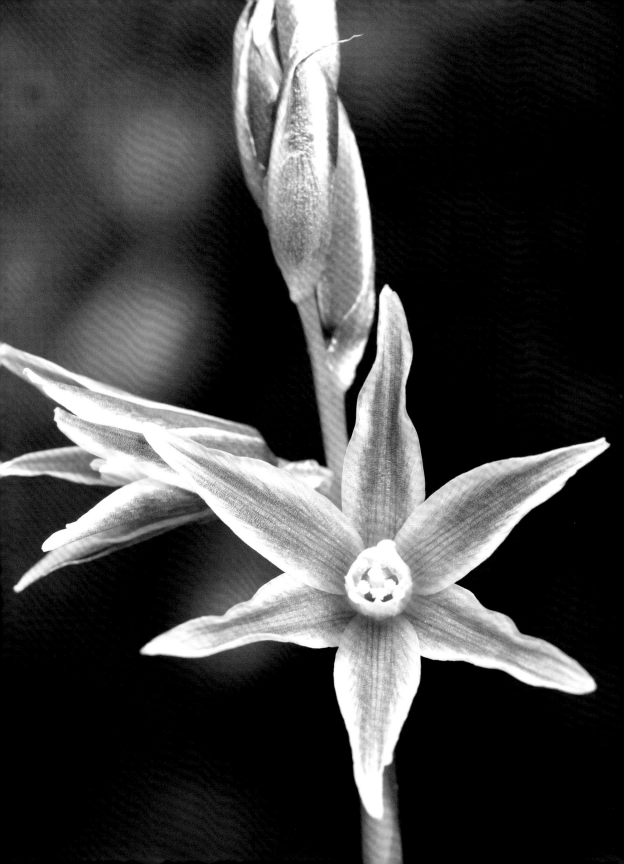

Paris quadrifolia

herb Paris

Type of plant
rhizomatous perennial

Hardiness
USDA Zones 5–8

Position
full or partial shade

Height
15–40 cm (6–16 in.)

Spread
30 cm (12 in.)

Paris quadripholia is also known as the true-lover's knot, possibly due to the form of the flower, which sits neatly like a knot at the intersection of four leaves. However, this nickname might also arise from the supposed effect of its seeds, which are said to have some of the nature of opium, and have been used as an aphrodisiac.

Often known by its common name of herb Paris, this curious plant may be easily concealed among other plants in the wild, where it naturally gathers in colonies of a dozen or so. *Paris quadrifolia* has a truly interesting form and it is worth giving it a higher profile in a cultivated situation. It has an attractive symmetry, reminiscent of a symbolic plant in a medieval tapestry. Usually four (but at times up to six) delicately tapering leaves range themselves evenly around a single star-shaped flower with white inner segments. The bloom, with its spidery tepals and distinctive protruding stamens, appears in mid spring and is followed by one blue-black seed capsule. Most of the plant is mid-green; the single colour allows the eye to concentrate on the shape of the starry leaf and flower cluster floating above a sea of curved and veined leaves.

Care and cultivation

Prefers full or partial shade and performs best in moist, fertile, leafy, soil and can tolerate very alkaline conditions. It can be divided, but will take a long time to recover and should not be replanted in the same soil; it is best to leave plants undisturbed so that they increase year by year.

Uses

On a streambank or in a shady border, woodland or peat garden.

Other recommendations

Paris polyphylla: a slowly spreading rhizomatous perennial with lance-shaped, mid-green leaves. Solitary spider-like flowers, each consisting of four to eight narrow green outer tepals and thread-like, yellowish green inner tepals, with numerous stamens, are borne in summer. Almost-spherical green capsules split to reveal shiny red seeds when ripe. Larger in all parts than *P. quadripholia*. Height 60–90 cm (24–35 in.).

Passiflora juliana
passion flower

Type of plant
climber

Hardiness
USDA Zones 10–11

Position
full light (greenhouse), or sun
or partial shade (indoors)

Height
2 m (6 ft.) or more

Spread
up to 1 m (3 ft.)

Many species of **Passiflora** *are grown as decorative plants but several are important economically in the tropics for their fruits. The fruit is known as passion fruit or water lemon, and it is the pulp covering the seeds that is edible.*

Passiflora juliana is a species of passion flower whose bright green sepals closely resemble petals. This species was only described in 1992 after being discovered in the wilds of southwestern Mexico. In frost-prone climates it is a greenhouse plant that will generally need minimum temperatures of 15°c (59°f) to thrive. The yellow-green flower appears on a purplish stem with an 'eye' of the same plummy colour—which serves to heighten the hue of the corona and reproductive parts. Without petals, this flower has a less cluttered appearance than the more common *P. edulis* and, minus the distraction of many colours, the structure of this juicy bloom can really be appreciated.

Care and cultivation
Plant in the border of the greenhouse, or in large pots of loam-based potting compost in full light, with shade from hot sun. Maintain humidity and water well when growing, but sparingly in winter. Apply a balanced fertilizer regularly during the growing season. *Passiflora juliana* grows vigorously in summer and autumn.

In milder climates, grow outdoors in moderately fertile, moist but well-drained soil in full sun or partial shade, with shelter from cold, drying winds. This plant will tolerate temperatures as low as 10°c (50°f) for short periods overnight. At low temperatures the top of the plant may be lost, but provided soil temperatures and conditions are good it will regrow from fleshy roots in the spring.

Uses
As a specimen plant in a greenhouse or conservatory. In warmer climates, train it over a pergola or arch, or allow it to scramble over small shrubs or through a tree.

Other recommendations
Passiflora coriacea (bat-leaf passion flower): a slender vine. Often creeping rather than climbing, it has leaves shaped like batwings with light green flecks. Flowers have sepals of yellowish green inside and no petals. Fruit follows. Minimum temperature 5°c (40°f). Height variable over 2 m (6 ft.).

Peperomia caperata 'Lilian'

Type of plant
perennial houseplant

Hardiness
USDA Zones 10–11

Position
greenhouse, or outdoors in
partial shade

Height
20 cm (8 in.)

Spread
20 cm (8 in.)

Many Peperomia *species and cultivars are epiphytes; they grow on top of or are supported by another plant, but do not depend on it for nutrition.*

At home in the tropics, this plant brings a touch of exoticism into the house. Species and cultivars of *Peperomia* have small, short-lived root systems but absorb water from the atmosphere and store it in their leaf cells. They are grown mainly for their fleshy, often long-stalked, elliptic or heart-shaped leaves. 'Lilian' has strange blooms that look almost primitive. The flowers are greenish white and produced in upright, sometimes branched spikes. Flowering is erratic but occurs mainly in late summer.

Care and cultivation

Under glass, grow in good-quality potting compost. Keep in bright light but not direct sun in the growing season, and in full light in winter. Water moderately in summer and sparingly in winter, preferably with tepid, soft water; allow compost to dry out between watering or the stems and roots will rot. From spring to summer, maintain moderate to high humidity by misting daily. Use liquid fertilizer each month.

Outdoors, grow in humus-rich, moist but well-drained soil in partial shade. This plant tolerates poor light and its fleshy leaves allow it to withstand some periods of drought. It needs a temperature above 10°C (50°F).

Uses

In tropical areas, grow as ground cover or in a border. In frost-prone areas, grow in a warm greenhouse or as a houseplant.

Other recommendations

The following species need a minimum temperature of 15°C (59°F).
Peperomia clusiifolia: an erect perennial with mid-green leaves often purple-tinged when young, and pale green flowers borne in spikes. Height 25 cm (10 in.).
Peperomia glabella (wax privet peperomia): a spreading perennial with trailing stems, mid-green leaves dotted with black and green flowers in spikes. Height 15 cm (6 in.).
Peperomia griseoargentea (ivy-leaf peperomia): a rosette-forming perennial with silvery grey leaves and green flowers in spikes. Height 20 cm (8 in.).

Plantago major 'Rosularis'
rose plantain

Type of plant
perennial

Hardiness
USDA Zones 4–8

Position
sun or partial shade

Height
30 cm (12 in.)

Spread
15–30 cm (6–12 in.)

Plantago major 'Rosularis' has been cultivated since medieval times. While most decorative species and cultivars of *Plantago* are grown for the characteristic rosettes of leaves that form at the plants' bases, *P. major* 'Rosularis' is desirable for its unusual form. Its emerald-green flower spikes develop a dense mass of green bracts that are shaped like a double rose. As the flowers grow and elongate on sturdy stems, they become rather like tiny, vivid-green Christmas trees—a must-have for the collector of green flowers.

Care and cultivation
Under glass, grow in four parts peat or leaf mould to one part grit or sharp sand. Seedlings come true to form. Outdoors, grow in preferably neutral to acid, moderately fertile, sharply drained soil in full sun. *Plantago major* 'Rosularis' does not like wet winters; otherwise, it is easy to grow, although apt to be weeded out by mistake when not in flower!

Uses
Grow in a herbaceous border or wildflower garden. It makes an unusual cut flower but does not have a very long vase life.

Other recommendations
Plantago patagonica: a small perennial with rosettes of hairy, mid-green leaves and long tails of small green flowers in summer. It likes a sunny position and good loam. Height 15–23 cm (6–9 in.).

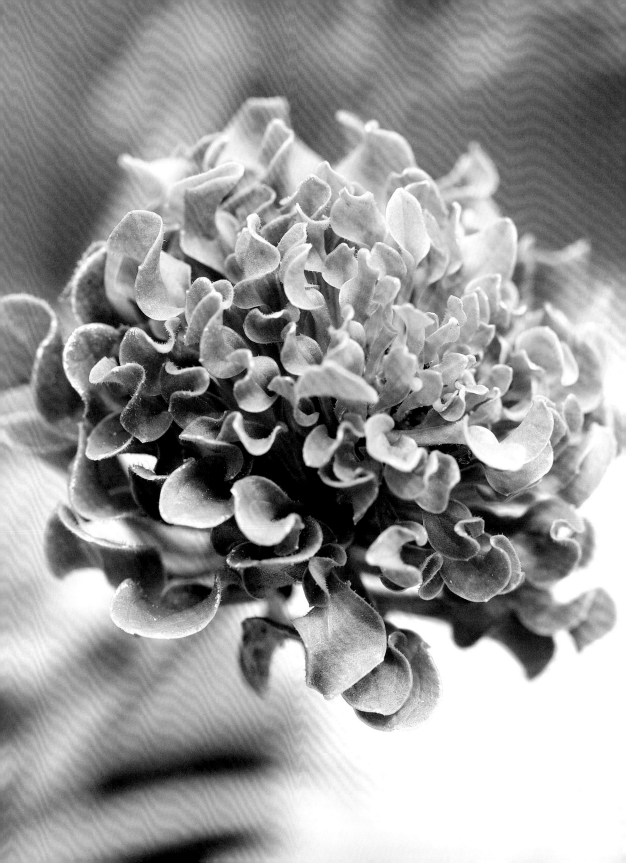

Polygonatum verticillatum 'Himalayan Giant'

whorled Solomon's seal

Type of plant
rhizomatous perennial

Hardiness
USDA Zones 5–9

Position
shade

Height
20–90 cm (8–35 in.)

Spread
25 cm (10 in.)

Polygonatum hirtum

Polygonatum verticillatum is a real enhancer of shady spaces. Its stems are more upright than those of most other polygonatums, and its leaves are more sword-like, with distinct parallel veining. Its bell-like flowers have a pronounced greenish tinge and they drip casually from the stem in a whorl; the leaves also radiate out at the same level from the stem, in a circular pattern (hence the species' common name of whorled Solomon's seal). What marks out the cultivar 'Himalayan Giant' is its extra stature and larger blooms. Its flowers last from late spring to midsummer, when they are followed by spherical red fruit.

Care and cultivation
This low-maintenance rhizomatous perennial should be grown in fertile, humus-rich, moist yet well-drained soil in full or partial shade.

Uses
Polygonatum species and cultivars are attractive in a shady border, woodland or rock garden and a good choice for planting under a north wall. They are excellent for cut flower arrangements, as they last well in water.

Other recommendations
Polygonatum biflorum: a rhizomatous perennial with arching stems and lance-shaped to broadly elliptic leaves. From late spring to midsummer it produces pendent, tubular, greenish white flowers, followed by spherical black fruit. Height to 40 cm–2 m (16–79 in.).
Polygonatum hirtum: a rhizomatous perennial producing erect stems with alternate, lance-shaped to ovate leaves. From late spring to midsummer, it produces pendent, tubular, green-tipped white flowers; they are followed by spherical black fruit. Height to 1.2 m (4 ft.).
Polygonatum odoratum (angled Solomon's seal): a creeping, rhizomatous perennial with arching, angular stems. In late spring and early summer it bears pendent, tubular, fragrant, green-tipped white flowers, followed by spherical black fruit. Height to 85 cm (34 in.).

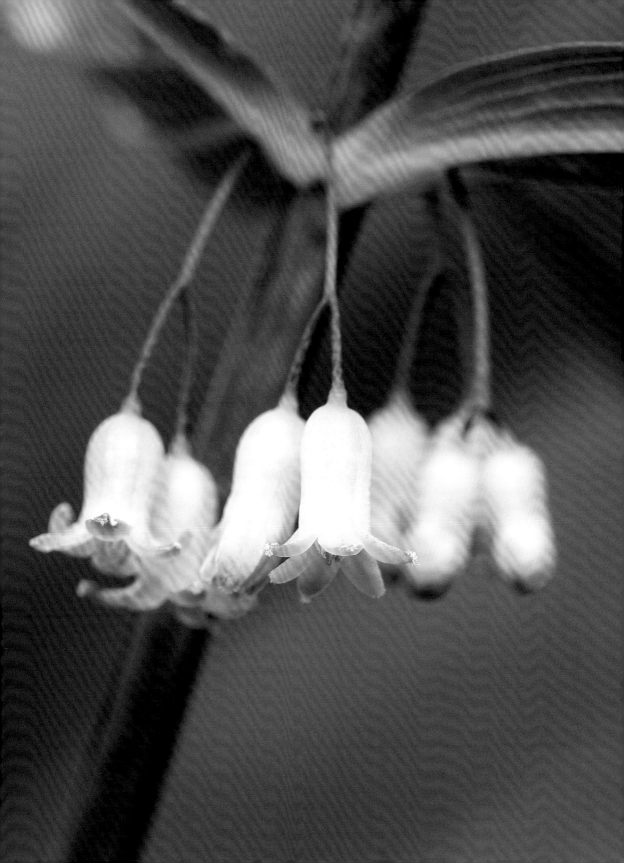

Ranunculus ficaria 'Green Petal'
buttercup

Type of plant
tuberous perennial

Hardiness
USDA Zones 4–9

Position
sun or partial shade

Height
5–10 cm (2–4 in.)

Spread
30 cm (12 in.) or more

One of many ornamental and unusual cultivars of *Ranunculus ficaria*, 'Green Petal' produces double flowers that begin as tight green rosettes before slowly opening into an informal arrangement of green petals with streaks of yellow. These unusual flowers emerge from late winter to mid spring and are completely sterile, meaning that no fruit follows. Before flowering begins it is a valuable foliage plant, coming into leaf in winter.

Care and cultivation
Very easy to please; plant in sun or light shade. This plant multiplies by tubers and can be invasive.

Uses
Ranunculus ficaria 'Green Petal' looks attractive in a pot, where it will likely produce leaves even earlier, often in autumn. It makes a delightful addition to an an early, small-scale floral arrangement. The flowers in spring are a good early source of nectar and pollen for insects. Contact with the sap may irritate skin.

Other recommendations
***Ranunculus ficaria* 'Green Wheel'**: a single-flowered form with green petals and green middles. Flowers late winter to late spring. Height 15 cm (6 in.).
***Ranunculus ficaria* Flore Pleno Group**: easy to grow with full greenish yellow double flowers in early spring to early summer. Height 15 cm (6 in.).

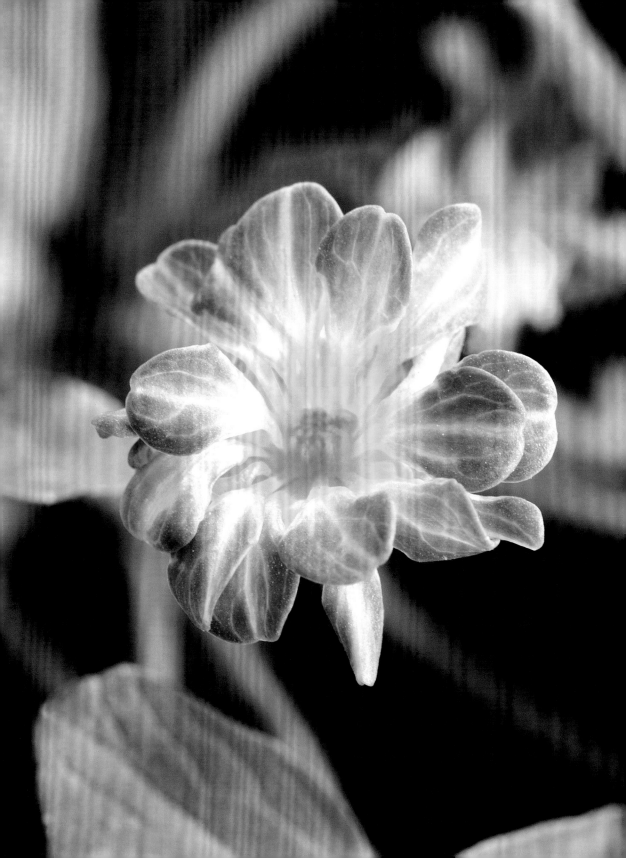

Ribes nigrum

blackcurrant

Type of plant
deciduous shrub

Hardiness
USDA Zones 5–9

Position
sun

Height
1.5–2 m (5–6 ft.)

Spread
1 m (3 ft.)

Ribes alpinum

A small shrub grown mainly for its nutrient-packed blackcurrants, *Ribes nigrum* is generally not renowned for its flowers. However, the small tubular to cup-shaped flowers of fresh yellow-green deserve more than a passing glance. Borne on pendent flowerheads in spring or early summer, they are an aesthetic bonus to a practical shrub. Look out too for other fruiting relatives in the flowering currant family that have verdant blooms.

Care and cultivation

Grow in moderately fertile, well-drained soil in full sun. (*Ribes laurifolium* will grow well in partial shade.) After fruiting, cut back flowered, fruited shoots to strong buds or young basal growth. On established plants, cut back about one quarter of the shoots to the base to promote replacement growth. If grown along a wall, cut back flowered, fruited shoots to within one to two buds of the permanent framework. Trim hedges after flowering or fruiting.

Uses

Grow in a shrub border, as a wall-trained shrub or as hedging.

From its fruit seeds, Ribes nigrum *produces an oil rich in gamma-lineolic acid (GLA), which is thought to promote cell immune function. It has also been found to have anti-inflammatory properties, and this bears out its widespread use in European folk medicine as an aid to reducing arthritic and rheumatic pain.*

Other recommendations

Ribes alpinum (mountain currant): a compact, mound-forming, many-branched, deciduous shrub with mid-green leaves. In spring it bears bell-shaped, greenish yellow flowers (males and females on separate plants). On female plants, these are followed by spherical dark red fruit. Height 60 cm (24 in.).

Ribes laurifolium (laurel-leaved currant): a spreading, spineless, evergreen shrub with dark green leaves. In late winter and early spring it bears cup-shaped, greenish yellow flowers (males and females on separate plants). Female flowers are followed by ovoid fruit, red at first, ripening to black. Height 1 m (3 ft.).

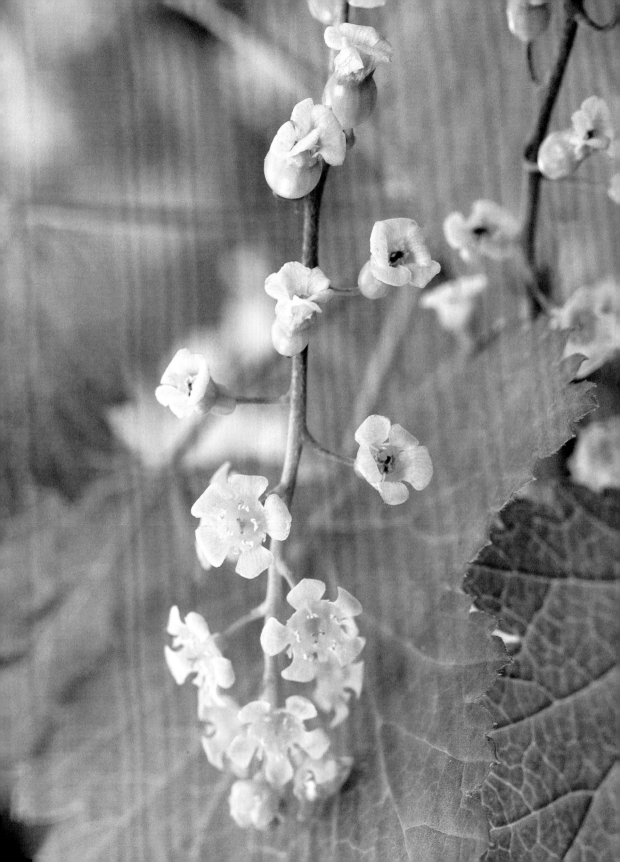

Rosa ×odorata 'Viridiflora'

Type of plant
shrub or climber

Hardiness
USDA Zones 7–9

Position
sun

Height
75 cm (30 in.)
(5 m [15 ft.] as a climber)

Spread
60 cm (24 in.)
(3–4 m [10–12 ft.] as a climber)

The distinctive *Rosa ×odorata* 'Viridiflora' can be grown as either a shrub or a climber. From its upright stems it produces shiny dark green leaves and sprays of double, rosette-shaped flowers. The green blooms are an oddity in the rose-breeding world, which loves to produce eye-catching colour or delicate whites. They are broad-bean green and the petals are really modified leaves; their colour ages to a purplish green, becoming flecked with crimson along the way. Sadly the flowers are unscented, but they continue from summer to autumn and the plant makes a good framework for not-too-vigorous climbers such as dainty clematis.

Care and cultivation

Roses tolerate a wide range of conditions, but usually prefer an open site in full sun. *Rosa ×odorata* 'Viridiflora' will tolerate partial shade and does not suffer from many common rose problems. It thrives on moderately fertile, humus-rich, moist but well-drained soil. Avoid planting a new specimen where roses have recently been grown.

Rosa 'Super Green'

Uses

Grow in a shrub or herbaceous border, at the edge of a woodland garden or as a framework for non-vigorous climbers. Unusual in a flower arrangement: cut the stem ends at a sharp angle, then plunge the first 2.5 cm (1 in.) of the cut ends in boiling water for twenty seconds and give them a long drink of tepid water before use.

Other recommendations

Rosa **'Green Ice'**: classed as a white rose, this miniature opens white and fades to sherbet green. Repeat flowers well, but has little to no fragrance. Height and spread 40 cm (16 in.).

Rosa **'Greensleeves'**: has pink semi-double blooms, borne in clusters on long stems, which change slowly into a true green colour which they hold for a very long time. Height 1.8 m (5.9 ft.).

Rosa **'Super Green'**: produces large, unscented pale green blooms, occasionally with a hint of burgundy to the petal edges. Height 60–90 cm (24–35 in.).

Rudbeckia occidentalis 'Green Wizard'

Type of plant
herbaceous perennial

Hardiness
USDA Zones 4–10

Position
sun or partial shade

Height
1.2–1.5 m (4–5 ft.)

Spread
just under 50 cm (20 in.)

Rudbeckias are typically known for their autumnal appearance and warm, flamboyant colouring. This is not so for 'Green Wizard', which has no colourful petals but relies on short green bracts to surround its black-coned centre. Rather like gladiolus, you may either love it or hate it; one critic has called it "undistinguished". However, without loud colour, there is no distraction from the distinctive *Rudbeckia* structure and 'Green Wizard' can be used to great effect in green plantings or late summer or autumn flower arrangements.

Care and cultivation
Grow in moderately fertile, preferably heavy but well-drained soil that does not dry out, in full sun or partial shade. It is easy to grow and has lush green foliage. Cut down stems in late autumn.

Uses
Grow in a border or naturalize in a meadow or woodland garden. Works well towards the rear of a border. It looks interesting in all-green plantings because of the dark cone-like flower centre. Flowers over a long period from late summer to late autumn, if not cut down by frost. It has a useful structure for flower arrangements and is good for drying.

Other recommendations
Rudbeckia hirta 'Irish Eyes' (syn. *R. hirta* 'Green Eyes'): has flower-heads with bright yellow ray-florets and green disc-florets. Height 60–75 cm (24–30 in.).

Salix hastata 'Wehrhahnii'

willow

Type of plant
deciduous shrub

Hardiness
USDA Zones 5–8

Position
sun

Height
1 m (3 ft.)

Spread
1 m (3 ft.)

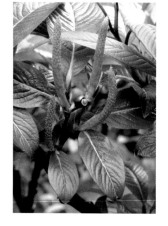

Salix fargesii

Willows are used to make wide range of products, from baskets to cricket bats to low-quality fuel. They also help to control soil erosion as their rapidly spreading root system stabilizes the soil along waterways. Small mammals and birds value willows too, using the trees as a habitat for food and as cover in early spring.

Many willows have a reputation for rapid and invasive growth. Not so *Salix hastata* 'Wehrhahnii'; it is slow growing and its scale suits most domestic settings. An upright shrub, it produces purple-brown new shoots which turn into bright green leaves. In early to mid spring, it produces its flowers on upright chunky male catkins up to 7 cm (3 in.) long. The flowers—coloured a gentle silvery green—arrive before the leaves emerge.

Care and cultivation
Like all willows, it dislikes shallow chalk soil. Grow in any deep, moist but well-drained soil in full sun.

Uses
Salix hastata 'Wehrhahnii' works best in a shrub border or wild garden.

Other recommendations
Salix fargesii: an upright, stoutly branched shrub with glossy green young shoots that turn red-brown, and red winter buds. Dark green leaves and slender green catkins are borne in spring. Height 3 m (10 ft.).
Salix fragilis (crack willow): a spreading tree with brittle, olive-brown shoots followd by glossy, dark green leaves that are silver underneath. Bears slender, pendent green female catkins in early spring, as the leaves emerge. Height 15 m (45 ft.).
Salix purpurea: a spreading shrub to an upright tree, it displays slender silvery-green female catkins in early and mid spring. Height 5 m (15 ft.).
Salix viminalis (basket willow, common osier): a fast-growing, upright shrub or tree with yellow-green shoots and slender, dark green leaves with silver undersides. Dense, crowded green catkins are produced in late winter and early spring, before the leaves. Height 6 m (18 ft.).

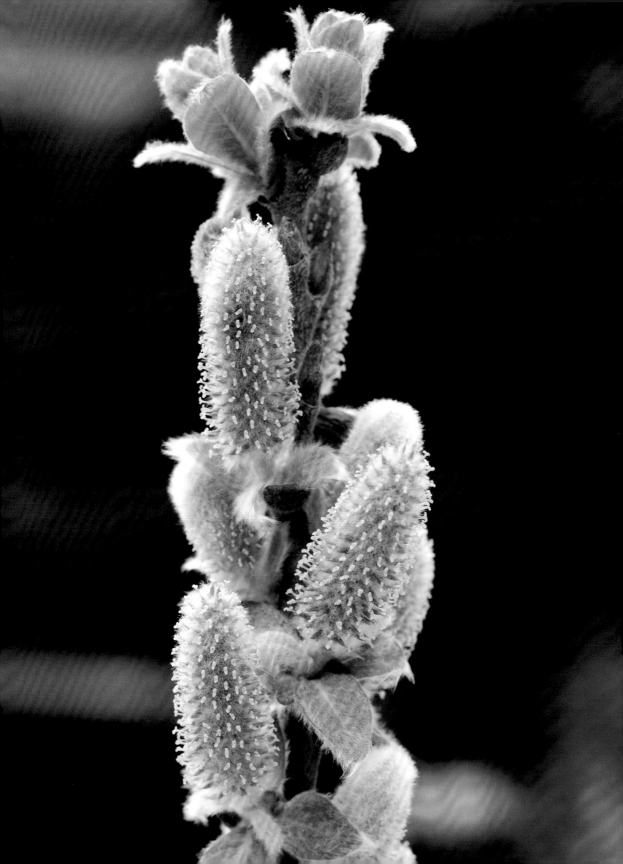

Sambucus racemosa 'Sutherland Gold'

golden elderberry

Type of plant
deciduous shrub

Hardiness
USDA Zones 3–8

Position
sun or partial shade

Height
3 m (9 ft.)

Spread
3 m (9 ft.)

Elderflowers can be made into a delicious non-alcoholic cordial by steeping them in boiling water with the addition of lemons, sugar and citric acid.

Historically used as both a garden plant and a cover for game birds, the bushy, red-berried shrub *Sambucus racemosa* has been cultivated for centuries. Its attractive cultivar 'Sutherland Gold' has finely cut leaves that are bronze when new, maturing to a golden colour; yellow foliage can be liable to sun scorch, but 'Sutherland Gold' has good resistance to this. Delicate greenish cream-coloured flowers arrive in mid spring, harmonizing with the luminous leaves—and in summer, shiny red berries are borne in heavy clusters.

Care and cultivation

Ideally, it should be grown in moderately fertile, moist but well-drained soil. However, this adaptable and vigorous shrub will grow even in waterlogged situations or very chalky ground. To achieve the best possible leaf colour, grow this shrub in a sunny position and prune it back to ground level in early spring.

Uses

Good for hedging and screens, even in coastal areas, and in wildlife or woodland gardens. If you are prepared for a very short vase life, the foliage, flowers and berries are attractive in informal flower arrangements.

Other recommendations

Sambucus racemosa **'Plumosa Aurea'**: very similar to 'Sutherland Gold' but more susceptible to sun-scorch. Height 3 m (9 ft.).

Sarracenia flava

yellow pitcher plant

Type of plant
carnivorous perennial

Hardiness
USDA Zones 5–8

Position
sun (outside), or shaded but with
plenty of light (greenhouse)

Height
50–90 cm (20–36 in.)

Spread
10 cm (4 in.)

Sarracenia flava is native to the United States and grows widely in the southern coastal plain. Along with a complex system of slippery surfaces, hairs, toxins and digestive secretions, it uses a distinctive pitcher-shaped device made from a rolled-up leaf to entrap and feast on its insect prey. The species name *flava* means 'yellow' in Latin, in reference to the greenish yellow flower that is borne above the pitcher in the spring. The flowers are large, with long, strap-like, dangling petals. Unfortunately they are infamous for having a strong smell of cat urine—probably not ideal for flower arrangements!

Care and cultivation

Where temperatures fall below –5°c (23°F), grow in a cold or cool greenhouse or on a sunny windowsill. In the greenhouse, grow in pots of a sphagnum moss, leaf mould and lime-free grit mix, in full light, shaded from hot sun. Apply liquid fertilizer monthly during the growing season. In summer, stand containers in trays of lime-free water. In winter, do not overwater; keep cool and well ventilated.

In warmer areas, grow in humus-rich, moist but sharply drained, acid soil in full sun. Irrigate with lime-free water. In mild areas plant in a woodland garden in dappled shade, or in a bog garden.

Sempervivum cantabricum ×montanum subsp. stiriacum

houseleek

Type of plant
evergreen succulent perennial

Hardiness
USDA Zones 3–8

Position
sun

Height
2–4 cm (0.75–1.5 in.)

Spread
to 4 cm (1.5 in.)

Rather like that of Aloe
vera, *the sap of the
houseleek is deemed to be
cooling and astringent; it
has been used as a soother
of burns and as a cure for
warts.*

This form of *Sempervivum*, or houseleek, is both evergreen and suc-
culent. It forms rosettes of juicy green leaves to create a verdant mat;
from this carpet, in summer, spring tiny, star-like flowers on upright
stems. After the effort of flowering, the rosettes of foliage are replaced
by new ones which emerge from a snaking surface-root system.

Care and cultivation
Grow in poor to moderately fertile, sharply drained soil, with added
grit, in full sun.

Uses
Grow this plant in a rock garden, scree bed, wall crevice, trough, or in
containers in an alpine house. It makes attractive ground cover when
planted between paving. It repays close scrutiny, so plant near to eye
level if possible.

Other recommendations
Sempervivum '**Commander Hay**': a succulent plant bearing rosettes
of glossy, deep red-purple leaves with mid-green tips. In summer, pro-
duces greenish red flowers. Height 10 cm (4 in.).
Sempervivum grandiflorum: a mat-forming succulent bearing
rosettes of very hairy, dark green leaves that are often tipped with
brown. In summer it produces yellow-green flowers, stained purple at
the bases. Height 10 cm (4 in.).

Setaria viridis

green foxtail

Type of plant
annual

Hardiness
USDA Zones 6–9

Position
sun

Height
45–100 cm (18–40 in.)

Spread
10–30 cm (4–12 in.)

The seed of Setaria viridis *is used in the same way as rice or millet; it is boiled or ground into flour. It can also be roasted and used as a coffee substitute.*

Also known as green bristle grass or wild millet, the green foxtail is an invasive grass in warm climates, but in the cooler areas of its range it is an interesting addition to the mixed border or wild garden where its relaxed shape makes good, informal background planting. On slender stems, solid heads of fluffy bright green flowers appear in late summer to mid autumn. *Setaria viridis* is pollinated by the wind, and its multiple flowerheads look particularly attractive moving in a breeze.

Care and cultivation

Sow seed in pots or plugs in a greenhouse, and plant out after the risk of frost has passed. Alternatively, sow directly in open ground in early autumn or from early spring onwards. *Setaria viridis* likes a sunny position in a well-drained soil. Ensure that the soil is free of weeds and well prepared before sowing. If seed is sown in situ in the middle of spring, the plant will flower later and may not ripen its seed in a cool summer. Seed usually ripens from early to mid autumn.

Uses

In a border or wild garden, *Setaria viridis* can be sited in full sun as it can withstand heat and is drought tolerant. It can be used as an edible grain. It makes a desirable cut flower due to the interesting texture of its flowerheads and long vase life.

Smyrnium perfoliatum

perfoliate Alexander

Type of plant
biennial or short-lived perennial

Hardiness
USDA Zones 6–10

Position
sun or partial shade

Height
60–150 cm (24–59 in.)

Spread
60 cm (24 in.)

The genus Smyrnium *is part of the carrot family and was named after the Greek* smurna *('myrrh') due to the scent of the seeds.* Smyrnium olusatrum, *which is edible and like a bitter version of celery, was once widely eaten but was replaced in popularity by superior strains of celery.*

The flowers of this biennial do not arrive until the spring of the second year after seed has germinated. Then, they appear as numerous, tiny, greenish yellow flowers arranged in a dome-like shape above rounded, bright yellow-green bracts—and their sharpness of colour is like a high note among a symphony of other late spring and early summer greens. After this energy burst, *Smyrnium perfoliatum* becomes dormant later in the summer.

Care and cultivation

Grow in moderately fertile, moist but well-drained soil in full sun to partial shade.

Uses

Ideal for naturalizing in a large border or in a wild or woodland garden, it naturalizes especially well in grass. It can spread prolifically; for instance, this plant has taken over as a weed in England's Royal Botanic Garden, Kew, adversely shading prized English bluebells.

Smyrnium perfoliatum provides unique cut flowers. Plunge the bottom 2.5 cm (1 in.) of stem into boiling water for twenty seconds, and then give it a long drink before using.

Teucrium scorodonia 'Crispum Marginatum'

wood sage

Type of plant
herbaceous subshrub

Hardiness
USDA Zones 5–10

Position
sun

Height
25 cm (10 in.)

Spread
30 cm (12 in.)

The common name for the genus Teucrium *is germander. Germanders are rich in essential oils and the oil of* Teucrium canadense *has traditionally been used in aromatherapy to calm hysteria and aid sleep. It is also applied to wounds as an antiseptic.*

Teucrium scorodonia 'Crispum Marginatum' is a low-growing plant with woody main branches and stems with non-woody tips that die back each year. Known as wood sage, this erect little shrub has sage-like foliage that resembles crêpe paper. Its leaves have wrinkled white edges, and above the foliage rise pairs of tiny yellow-green flowers on spiky, branching flower stems. The bell-shaped flowers are delicately pendent and although they are not fragrant, the foliage is aromatic.

Care and cultivation

This plant dislikes limey soils. Grow in well-drained, preferably neutral to acid soil in full sun. Small forms of *Teucrium* such as *T. scorodonia* 'Crispum Marginatum' keep their compact habit better in poor, gritty soil. This plant is largely trouble-free.

Uses

Teucriums are grown for their attractive habit, aromatic foliage and flower clusters. They have a variety of garden uses: the small forms such as *Teucrium scorodonia* 'Crispum Marginatum' are suitable for rock gardens, raised beds or troughs. Grow the shrubs in a sheltered border or against a warm, sunny wall, or use for hedging in mild climates. They are marvellous for that patch of dry shade.

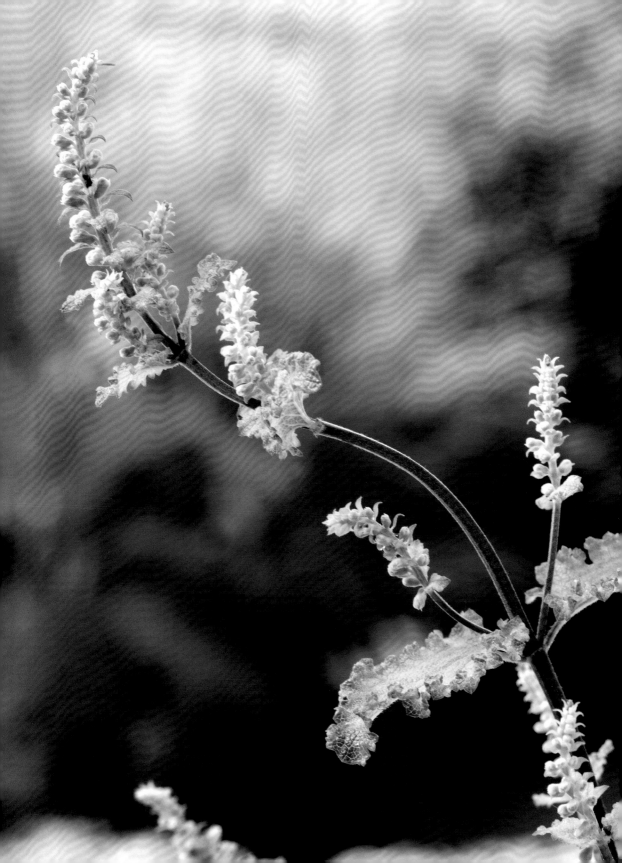

Thalictrum minus

lesser meadow rue

Type of plant
tuberous perennial

Hardiness
USDA Zones 6–9

Position
partial shade

Height
up to 1 m (3 ft.)

Spread
up to 1 m (3 ft.)

Thalictrums are native mainly to temperate areas of the northern hemisphere where they are commonly known as meadow rue. *Thalictrum minus*, the lesser meadow rue, has a stately appearance; with its delicate, finely cut leaves, it resembles a maidenhair fern. The tiny flowers are without petals and appear on tall stems well above the mass of foliage in mid to late spring. Graceful in form, it provides an elegant silhouette in shady areas.

Care and cultivation

Thalictrum minus grows best in areas with cool, damp summers—so mulch it well in hot climates. Plant in moist, humus-rich soil in partial shade. Do not over-fertilize as this will promote weak growth.

Uses

Thalictrum minus is suitable for a shady rock garden, peat bed, alpine house or woodland garden. Its airy form makes it an excellent background plant in a border, as long as it is given moisture and shade.

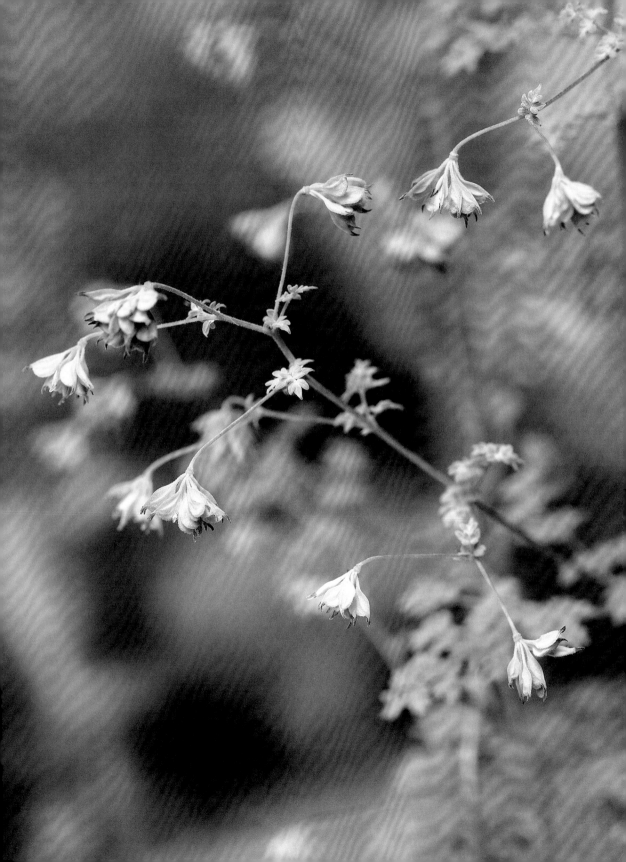

Tulipa 'Spring Green'

Type of plant
bulbous perennial

Hardiness
USDA Zones 3–7

Position
sun and partial shade

Height
30 cm (1 ft.)

Spread
20 cm (8 in.)

Tulipa 'Spring Green' is arguably the best of the green-flowered tulips. Its ivory-white to pale yellow flowers are striped with lettuce-green; they come into bloom in mid to late spring, and are well worth the wait. Standing erect on tall stems, the flowers bring a mix of freshness and attention-grabbing chic to the garden.

Care and cultivation

Grow in fertile, well-drained soil in sun, sheltered from strong winds. However, blooms last longer in slightly more shaded or north-facing aspects. They dislike excessive wetness. Plant bulbs at a depth of 10–15 cm (4–6 in.) in late summer or autumn and lift the bulbs annually, once the leaves have died down. Store them in a cold greenhouse. Replant the largest bulbs, and grow on the smaller ones for a year in a nursery bed.

Uses

Use in a bed, border or cutting garden. 'Spring Green' can tolerate more north-facing aspects with shelter, and can really brighten up a shaded corner. It looks great in containers. If the bulbs are not dug up and replaced each year the blooms will become progressively smaller.

A good cut flower. Strip the bottom leaves and wrap in paper to keep stems upright, before standing them in water for eight hours. If bent stems soak up water, they will remain that way; depending on the arrangement, however, this can still be attractive.

Other recommendations

Tulipa **'Flaming Spring Green'**: looks similar to 'Spring Green', but with a streak of red. Mid to late spring. Height 40 cm (16 in.).
Tulipa **'Greenland'**: produces flowers with green stripes on pale pink backgrounds. Mid to late spring. Height 50 cm (18 in.).
Tulipa **'Viridichic'**: an exotically shaped tulip with green, pastel pink and white flowers in mid to late spring. Height 45 cm (14 in.).

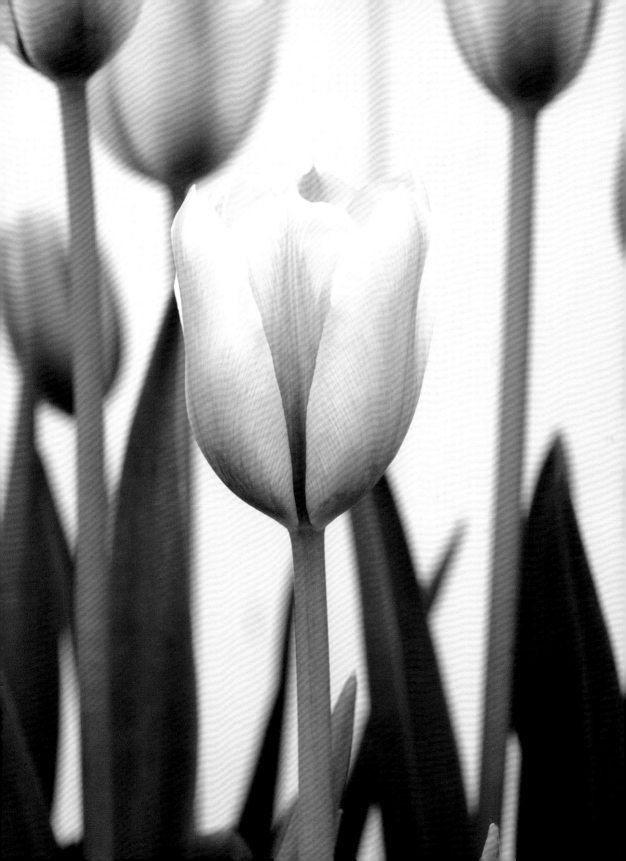

Veratrum viride

false hellebore

Type of plant
rhizomatous perennial

Hardiness
USDA Zones 3–9

Position
partial shade

Height
to 2 m (6 ft.)

Spread
60 cm (24 in.)

Dubbed the 'false hellebores', veratrums are popular in England but less so in the United States, despite being native to North America. This might be in part due to slowness of propagation; they do not take kindly to division or re-siting, recovering slowly from the experience, and seed sown takes five years to become a decent-sized plant. However, this investment of time is repaid by the sight of the flowers of *Veratrum viride*, which are almost fluorescent in their greenness. The star-shaped, numerous blooms froth into life in late spring to midsummer and look wonderful against purple foliage like that of certain *Cotinus* specimens.

Care and cultivation
Grow in deep, fertile, moist but well-drained soil, with added well-rotted organic matter, either in partial shade or in full sun where the soil does not dry out. *Veratrum viride* tolerates wet soil. Provide shelter from cold, drying winds.

Uses
Easy to grow in a moist, shady site, in a mixed or herbaceous border or peat bed, or in a woodland or wild garden. Foliage can become shabby, so conceal damage behind other plants. (Be careful when handling these plants, as they can irritate skin. All parts of the plant are highly toxic if swallowed.)

Other recommendations
Veratrum album (false/white hellebore): a rhizomatous perennial with leaves that are hairless on top and hairy-veined on the bottom. In early and midsummer it bears numerous star-shaped, greenish white to fully white flowers. Height to 2 m (6 ft.).

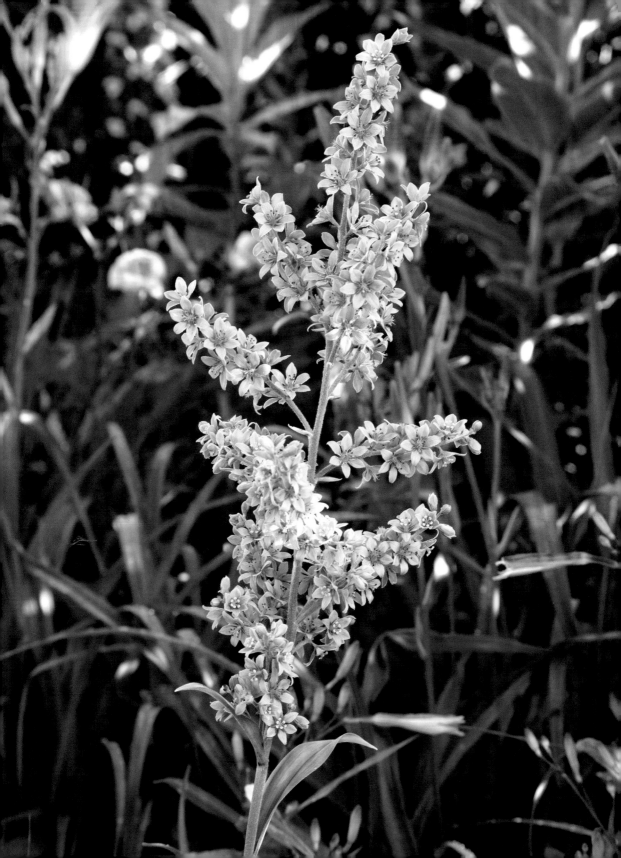

Viburnum opulus 'Roseum'
snowball tree

Type of plant
deciduous shrub

Hardiness
USDA Zones 4–7

Position
sun or partial shade

Height
4 m (12 ft.)

Spread
4 m (12 ft.)

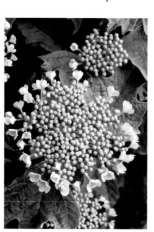

Viburnum opulus

Viburnum opulus 'Roseum' (syn. 'Sterile') is a vigorous, bushy plant with a rounded habit and leaves that become purple-tinted in autumn. The generous flowers, which appear in late spring and early summer, lead to its common name of snowball tree. The large spherical clusters of green-tinted white blooms are sterile, but this is a small price to pay as the blooms are satisfyingly opulent and sometimes add value by becoming pink-flushed as they age.

Care and cultivation
Grow in any moderately fertile, moist but well-drained soil in full sun or partial shade. In frost-prone regions, shelter viburnums from cold, drying winds. Remove dead or damaged growth mid spring. Trim or lightly cut back shoots that spoil symmetry.

Uses
Grow in a shrub border or woodland garden. Good for floral decoration. When cutting for flower arrangements, bear in mind the remaining shape of the bush.

Other recommendations
Viburnum macrocephalum (Chinese snowball bush): a rounded shrub, sometimes tree-like, semi-evergreen or evergreen in mild climates, deciduous where winters are severe. It has sterile white flowers but the young flowerheads (to 15 cm [6 in.] across) are decidedly lime-green before maturing to white. Does not bear fruit. Height 5 m (15 ft.).
Viburnum opulus (Guelder rose): a vigorous, bushy shrub with maple-like leaves that turn red in autumn. In late spring and early summer it bears flat lacecap-like flowers; the fertile central flowers are lime-green before they mature to white and are surrounded by showy white sterile-florets. Spherical, fleshy red fruit follows. Height 5 m (15 ft).

Zantedeschia aethiopica 'Green Goddess'

arum lily, calla lily

Type of plant
rhizomatous perennial

Hardiness
USDA Zones 8–10

Position
full sun to partial shade

Height
90 cm (35 in.)

Spread
60 cm (24 in.)

Zantedeschia aethiopica
'Captain Eskimo'

The genus *Zantedeschia*, including plants known as arum lilies (or, in the United States, calla lilies), remains evergreen in mild areas. It has clumps of bright green, arrowed leaves and a 'flower' that is actually a spathe in the form of a curling, enclosed leaf from which a finger-like spike, or spadix, emerges. In the case of 'Green Goddess', the white spathes typical of the species are suffused green almost as if the white bract is dipped in viridian paint which seeps from the edges towards a whiter centre. Some critics find this greenness means that the spathe is not sufficiently distinguished from the foliage; however, its colour and fragrance make it a delight to flower-arrangers—especially those who appreciate green flowers.

Care and cultivation

Outdoors, grow in moist, humus-rich, soil in full sun or partial shade. This plant will withstand less well-drained soil than other forms of *Zantedeschia*. In frost-prone areas protect with a deep mulch in winter. It may take a few years to establish in temperate areas. Propagate by dividing tuberous rhizomes. Flowers will last longer up to three weeks in partial shade. As a marginal aquatic plant, grow in a planting basket 25–30 cm (10–12 in.) wide, filled with rich loamy soil, in water up to 30 cm (12 in.) deep.

Uses

Can be grown on pond margins, or in a well-irrigated border. It also works well as houseplant in a container, providing it is kept well watered, and makes a marvellous, long-lasting cut flower; give flower stems a long drink before use. All parts of plant are poisonous if ingested.

Other recommendations

Zantedeschia aethiopica **'Captain Eskimo'**: has blue-green leaves that are sometimes slightly spotted and dashed white, while spathes are a yellowish green colour. Height 50–60 cm (20–24 in.).

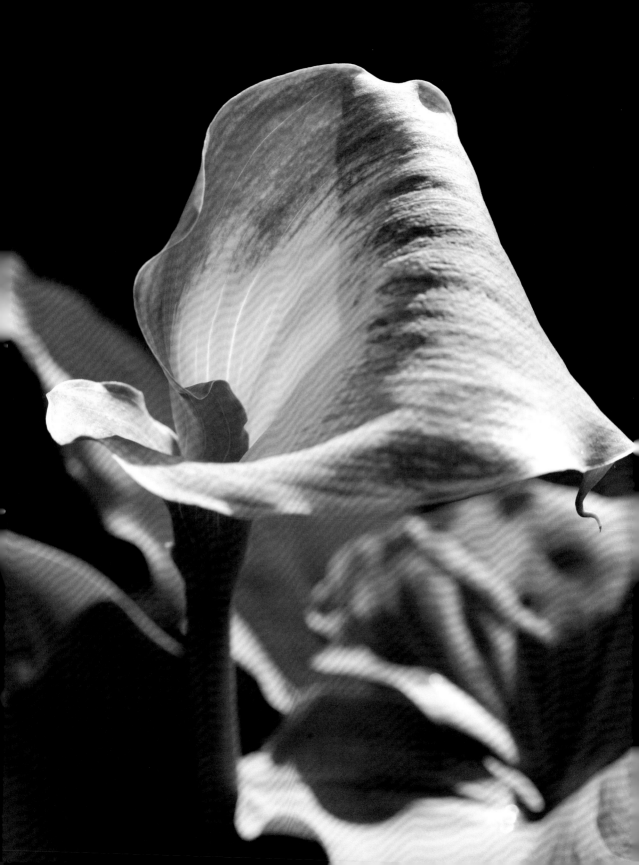

Zigadenus elegans

white camas

Type of plant
bulbous perennial

Hardiness
USDA Zones 3–9

Position
sun or partial shade

Height
70 cm (28 in.)

Spread
8 cm (3 in.)

Zigadenus elegans is a perennial herb native to North America. When well established in cool woodland soil, it produces beautiful stems of small, star-shaped flowers from a base of delicate, strap-like leaves. The flowers are white flushed with green or yellow-green, and closer inspection reveals delicate lime-coloured nectaries. It blooms from mid to late summer when shady areas can benefit from a chic shot of bright green freshness. However, beware if using in a garden with children or close to grazing land; this beauty is highly toxic.

Care and cultivation

Easy to propagate from seed or bulb, *Zigadenus elegans* likes deep, fertile, moist but well-drained soil in sun or partial shade.

Uses

Good for a shady border or woodland garden. All parts of the plant are poisonous to humans and livestock if ingested.

Other recommendations

Zigadenus fremontii (star lily): a robust, bulbous perennial with linear, greyish green leaves and star-shaped, creamy white flowers in early summer. Requires dry summer dormancy. Unlike *Z. elegans*, it prefers full sun. Height 70 cm (28 in.).

Zigadenus elegans *contains steroidal alkaloids, including* zygacine. *It has been known to cause poisoning in sheep, and may have poisoned cattle as well. If accidentally ingested, it can also cause severe symptoms in humans. However,* Z.elegans *is about seven times less toxic than* Z. venenosus, *known as death camas. Problems for livestock occur commonly in early spring because this plant is often available before other foodstuff is plentiful.*

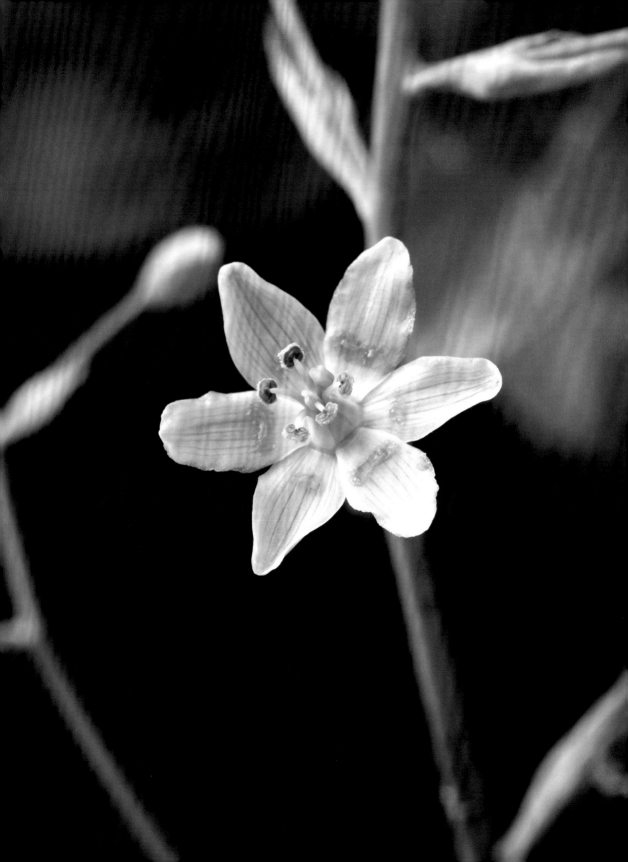

Hardiness Zones

In the United Kingdom, we usually refer to plants in terms of their relative hardiness, describing them as fully hardy, frost-hardy, half-hardy or frost-tender. In other parts of the world, though, describing hardiness is more complex due to the wide variety of climatic conditions.

The United States Department of Agriculture (USDA) divides North America into eleven Hardiness Zones—Zone 1 being the coolest and Zone 11 the warmest. These Zones serve as a guide to help gardeners select plants likely to thrive in their areas. The lowest-numbered Zone in the plant's recommended range corresponds to the lowest temperature at which that plant is generally expected to thrive. As can be seen on this map, the colder Zones are usually found at higher latitudes and elevations while the warmest Zone includes a tropical area found only in Hawaii and southernmost Florida.

If you live outside North America, you can roughly translate the USDA Hardiness Zones by finding out how low temperatures can reach in your area. Then, use the chart provided here to to find your corresponding zone.

Keep in mind, though, that the average minimum temperature is not the only determinant of whether a plant will thrive in your particular garden. Factors like soil types, rainfall, daytime temperatures, day length, wind, humidity and heat all play a role, and even within a single neighbourhood there may be microclimates that affect how plants grow. USDA Hardiness Zones should therefore be used only as rough guidelines when choosing plants for your garden.

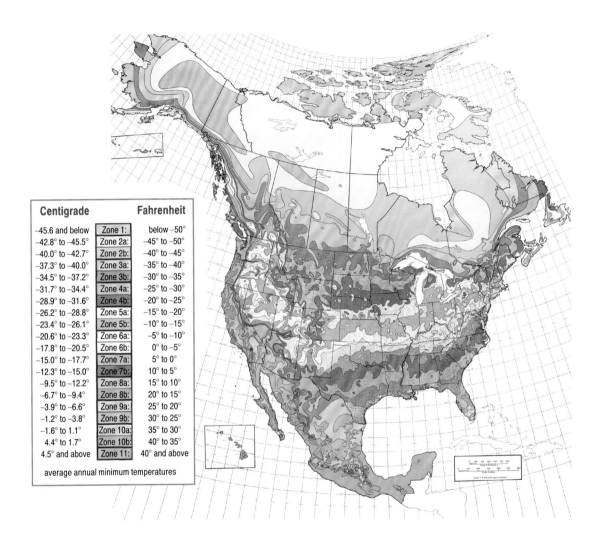

Centigrade		Fahrenheit
−45.6 and below	Zone 1:	below −50°
−42.8° to −45.5°	Zone 2a:	−45° to −50°
−40.0° to −42.7°	Zone 2b:	−40° to −45°
−37.3° to −40.0°	Zone 3a:	−35° to −40°
−34.5° to −37.2°	Zone 3b:	−30° to −35°
−31.7° to −34.4°	Zone 4a:	−25° to −30°
−28.9° to −31.6°	Zone 4b:	−20° to −25°
−26.2° to −28.8°	Zone 5a:	−15° to −20°
−23.4° to −26.1°	Zone 5b:	−10° to −15°
−20.6° to −23.3°	Zone 6a:	−5° to −10°
−17.8° to −20.5°	Zone 6b:	0° to −5°
−15.0° to −17.7°	Zone 7a:	5° to 0°
−12.3° to −15.0°	Zone 7b:	10° to 5°
−9.5° to −12.2°	Zone 8a:	15° to 10°
−6.7° to −9.4°	Zone 8b:	20° to 15°
−3.9° to −6.6°	Zone 9a:	25° to 20°
−1.2° to −3.8°	Zone 9b:	30° to 25°
−1.6° to 1.1°	Zone 10a:	35° to 30°
4.4° to 1.7°	Zone 10b:	40° to 35°
4.5° and above	Zone 11:	40° and above

average annual minimum temperatures

Acknowledgements

We would like to thank those who have been kind enough to share their gardens and knowledge with us, notably Elaine Horton, Ronald Mackenzie, Rod and Jane Leeds, Paul Williams, Sue Spielberg, John Vanderplank, Timothy Walker of the University of Oxford Botanic Garden, and Julie Ritchie. Additionally, we are grateful to the following nurseries and garden centres.

Crûg Farm Plants
Griffith's Crossing
Caernarfon, Gwynedd
LL55 1TU North Wales
Telephone: 01248 670232
Email: info@crug-farm.co.uk
www.crug-farm.co.uk

Tinpenny Plants
Tinpenny Farm
Fiddington, Tewkesbury
Gloucestershire
GL20 7BJ England
Telephone: 01684 292668
Email: elaine@lime.ws

Allwoods
London Road
Hassocks, West Sussex
BN6 9NB England
Telephone: 01273 844229
Email: info@allwoods.net
www.allwoods.net

Kelways Ltd
Barrymore Farm
Langport, Somerset
TA10 9EZ England
Telephone: 01458 250521
Email: sales@kelways.co.uk
www.kelways.co.uk

Cotswold Garden Flowers
Sands Lane
Badsey, Evesham
Worcestershire
WR11 7EZ England
Telephone: 01386 833849
Email: info@cgf.net
www.cgf.net

Pop's Plants for Primula Auriculas
Pop's Cottage, Barford Lane
Downton, Salisbury, Wiltshire
SP5 3PZ England
Telephone: 01725 511421
Email: enquiries@popsplants.com
www.popsplants.co.uk

Ashwood Nurseries
Aswood Lower Lane
Ashwood
Kingswinford, West Midlands
DY6 0AE England
Telephone: 01384 401996
Email: mailorder@ashwoodnurseries.com
www.ashwood-nurseries.co.uk

John Vanderplank
National Collection of Passiflora
Lampley Road
Kingston Seymour
Clevedon, North Somerset
BS21 6XS England

Wootens of Wenhaston
Blackheath
Halesworth, Suffolk
IP19 9HD England
Telephone: 01502 478258
Email: sales@woottensplants.co.uk
www.woottensplants.co.uk

Index of Plant Names